IMAGES
of America

OCEANO

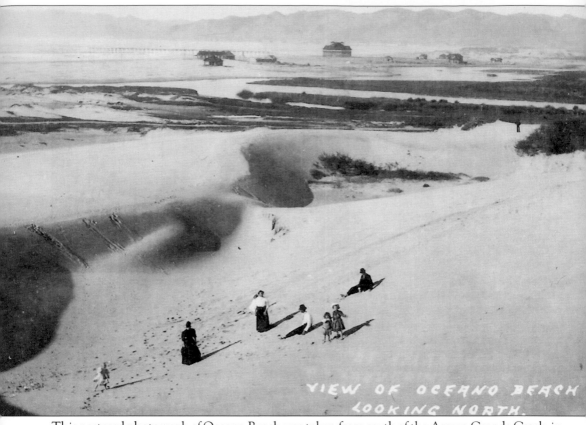

This postcard photograph of Oceano Beach was taken from south of the Arroyo Grande Creek in the early 1900s in what is now the Dune Preserve. The larger building on the left is the Oceano Beach Hotel, which is shown on the cover of this book. The building on the far side of the Oceano Lagoon with twin gazebo towers is the Oceano Pavilion. The large building to the right of the pavilion later became the new Oceano Beach Hotel, using the sign from the earlier hotel on the beach. (Photograph by Virgil Hodges; courtesy of Bennett-Loomis Archives.)

ON THE COVER: This view of the Oceano Beach Hotel is looking north toward the Oceano pavilion on Pier Avenue. The hotel faces the beach and was built in the very early 1900s. It survived until around the early 1910s. Pictured here are Rose Hodges; Amy Hodges; their mother, Sarah Hodges; and unidentified. Mrs. Hodges was also the mother of Virgil Hodges, who took this photograph. (Photograph by Virgil Hodges; courtesy of Bennett Loomis Archives.)

IMAGES
of America

OCEANO

Linda Austin and Norm Hammond

ARCADIA
PUBLISHING

Published by Arcadia Publishing
Charleston SC, Chicago IL, Portsmouth NH, San Francisco CA

Printed in the United States of America

Library of Congress Control Number: 2010921993

For all general information contact Arcadia Publishing at:
Telephone 843-853-2070
Fax 843-853-0044
E-mail sales@arcadiapublishing.com
For customer service and orders:
Toll-Free 1-888-313-2665

Visit us on the Internet at www.arcadiapublishing.com

Dedicated to the people of Oceano and the spirit of the founding members of the Oceano Women's Club and the Oceano Improvement Association.

CONTENTS

ACKNOWLEDGMENTS

The authors wish to express their appreciation to those who have provided their support and assistance in this project. They have shared many of their memories and stories with us and allowed access to many of their records, photographs, and other information without which this project would not have been possible. We sincerely apologize to those who may have been overlooked.

We would like to thank the following contributors: Gordon Bennett (Bennett-Loomis Archives), Jean Hubbard, Lesley Gerber Benn, Oceano Women's Club, David Angello family, Effie McDermott, Howard Austin, Rubye Lovern collection, Anita Shower, Georgina Annecchini Silva, Geneva Beck, Gene Beck, Dolores Cardoza, Philip T. Davis, Evelyn Tallman, Mark Weedon, Peggy Weedon, Stadley family, Jerry Miller, Janice Hilton, Jon Gateley, Manuel Sebastian, Irene Rodin, Erma Kendrick, Cindy Winter, Armand Carpentier Jr., and Jeanne Storton.

Photographs and information were also provided through a number of organizations, including the following: Gordon Bennett of Bennett-Loomis Archives; Harold E. Guiton Family Collection (HEG); Oceano Depot Association (ODA); *Times-Press Recorder*; and the South County Historical Society. Photographs by Norm Hammond (NRH).

All royalties earned from the sales of this book will benefit the Oceano Depot Association.

INTRODUCTION

Oceano is a beach town on the central coast of California, almost midway between San Francisco and Los Angeles. The Chumash Indians were the earliest known inhabitants of the area, and they lived here for at least 11,000 years. Artifacts and middens of the Chumash abound beneath the houses and buildings, streets, lawns, and vacant lots of Oceano and are often uncovered by the wind in the vast sand dune complex just south of town.

Although the rich alluvial soil of the low-lying areas of Oceano made for excellent farming and ranching, the area that would become Oceano was sparsely populated during the time of the Mexican Land Grants. Several large dairy farms were later established in this area of South San Luis Obispo County during the 1860s and it became known as "Cow Heaven."

In the early days, Oceano went by different names such as "the Rice Place," "the Cienega" (which means "swampy place" in Spanish), and for a short while, it was called Deltina. On June 7, 1893, the first map of the town of Oceano was filed for record, designating a rail yard and depot grounds. The year after the railroad arrived in 1895, a new depot stood on the site labeled "Southern Pacific Depot Grounds."

In 1901, the last link of the Southern Pacific Coast route between San Francisco and Los Angeles was completed and brought a fresh influx of people and commerce into the area. A wave of prosperity swept over the little town and the area now enjoyed overnight passenger, freight, and telegraph service.

Real estate promoters soon began casting their eyes on the area west of the original town site, and from 1905 to 1907, resorts were created in the area of the ocean and dunes. People living in the interior San Joaquin Valley who made their way to the area during the hot summer months enjoyed the cool ocean breeze, and some bought summer vacation homes. Oceano was soon being promoted as the "Atlantic City of the West," a resort city complete with an ideal climate, a boardwalk, and a pier. A railroad spur from the Oceano station carried potential investors to the dance pavilion on the beach.

The famed pismo clam had always been in great abundance along this stretch of the central coast. Oceano had such an abundance of clams that they were often dug up with horse-drawn plows and taken away in wagons as feed for chickens and pigs. Clams were also greatly enjoyed by people, and digging for them was a favorite pastime for tourists and locals. Commercial clam digging was also a thriving industry in this area, until 1948 when it was no longer permitted. Although clams have become scarce in recent times, surf fishing remains a favorite pastime.

Produce farming has always been an important industry around Oceano and it remains that way today. The soil and climate of this area made it ideal for growing celery, which was one of the main crops during the 1930s and 1940s. Throughout the 1950s, a celery festival was promoted in Oceano with parades, dances, the crowning of a celery queen, and other social events.

The Oceano of today is a major tourist destination. A primary attraction is the Pismo Beach State Park that is adjacent to Oceano. The park includes areas for camping, a beach that runs

12 miles south of town to the rocky headlands of Mussel Rock, a freshwater lagoon, and portions of the sand dunes that border the town to the south. Many people come to enjoy the unique experience of driving on the last remaining beach in California where it is still allowed. The more adventurous can enjoy driving all-terrain vehicles inland into the high dunes themselves.

Visitors continue to be attracted to the coastal lifestyle of the area. They enjoy local restaurants, first-class live entertainment at the Great American Melodrama, and the 1904 Oceano railroad depot. The depot has been preserved as a classic type 22 Southern Pacific railroad depot and was designated a Point of Historical Interest in 1991. The depot also serves as a museum for the community and is open to the public, hosting a number of social events throughout the year.

Pier Avenue in Oceano does not end where the pavement stops; it continues on down to the sands of the beach. It has always been the primary vehicle access to the beach and sand dunes. Pier Avenue also once served as a point of entry into the dunes for a colorful group of people who lived there known as "Dunites." Oceano in the past had been promoted as being the "Atlantic City of the West," but today it is better known as the "Gateway to the Dunes."

One

Early Times in Oceano

The Chumash Indians were the first inhabitants of Oceano. They lived in this area at least 5,000 years ago and were here when the great pyramids of Giza were being constructed. Chumash artifacts continue to be uncovered in town during earth-moving and construction projects. These artifacts are among the few remaining traces that are left of those people who once lived here. (NRH.)

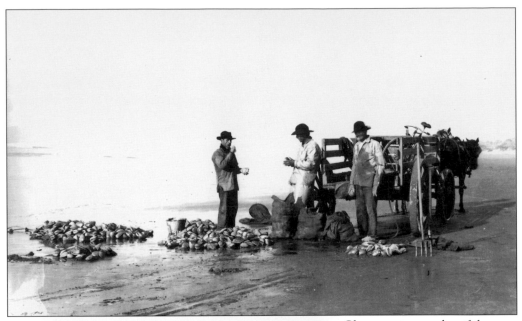

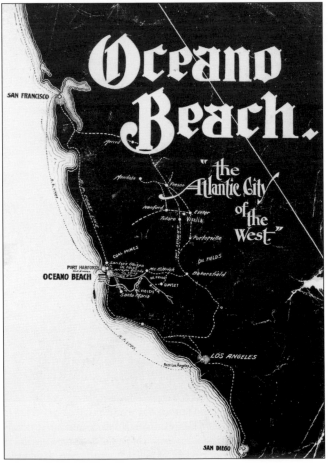

Clams were very plentiful on the beaches of the central coast of California until relatively recent times. They were an essential food source for the Chumash in this area and for those who came later. Stories abound of clams being so abundant in the early 1900s, they were often plowed up on the beach and fed to farm animals. (Photograph by Virgil Hodges; courtesy of Bennett-Loomis Archives.)

Early real estate developers felt that Oceano would make an excellent beach resort, like Atlantic City in New Jersey. This brochure was published by the Oceano Beach Land and Improvement Company in 1907 promoting Oceano as the "Atlantic City of the West." In some respects, Oceano was similar to the Atlantic City in New Jersey because it was on the coast, had a railroad, a boardwalk, and a large dance pavilion. (HEG.)

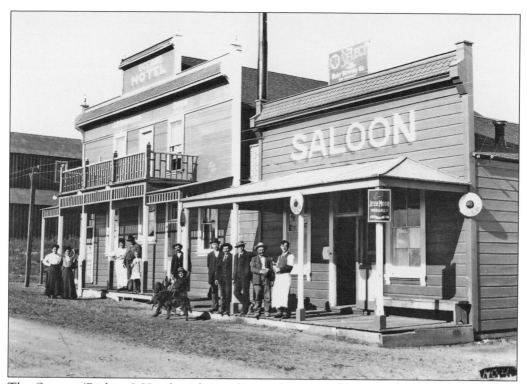

The Oceano (Righetti) Hotel, with its adjacent Oceana Saloon, was built in 1902 and was located on the northeast corner of Highway 1 and Beach Street. The hotel was a block south of the original location of the railroad depot and was known for its delicious 75¢ Sunday chicken dinners. The hotel survived until the 1960s. (Photograph by Virgil Hodges; courtesy of Bennett Loomis Archives.)

These tokens were issued by the Oceana Saloon and were good for one 10¢ drink. Oceana is a misspelling of Oceano that first appeared on railroad timetables in 1896. The timetables were soon corrected, but the name remained for the saloon. Sometime after Prohibition ended, a saloon with the same misspelled name appeared a block north on Highway 1 from the location of the Oceano Hotel. (NRH.)

11

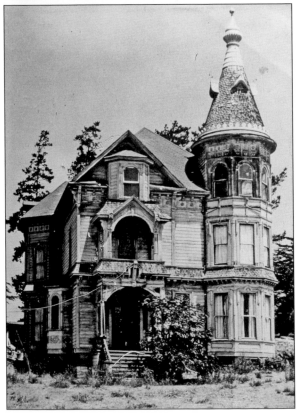

The Baughman home was built in 1894. It was originally called the Captain's House because the two round porthole windows in the front were believed to have come from an old ship. The house and neighboring Coffee Rice mansion were purchased by Dr. William Dower of the Temple of the People sometime after 1903. Dr. Dower used the home as his personal residence, and the Coffee Rice mansion was used as his sanatorium. (Courtesy of South County Historical Society.)

Originally constructed in anticipation of the arrival of the Southern Pacific Railroad, this mansion was built by Coffee Rice around 1885. It had some 20 rooms and running water, which was very uncommon in this area at that time. The mansion is still standing on Highway 1, between Twenty-fifth and Elm Streets. (Courtesy of Pam Carlson.)

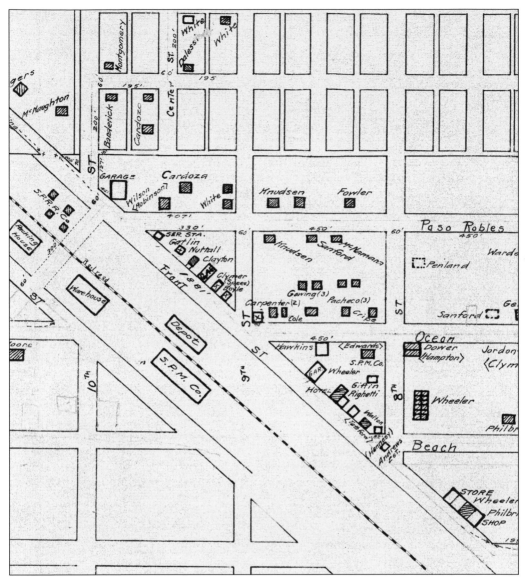

This map shows Oceano as it was in the early 1920s. Front Street also goes by the name Highway 1. Two of the four "S.P.R.R." buildings seen left of the intersection of Paso Robles and Front Streets are the section foreman's home and a bunkhouse for the men who worked the Oceano section doing railroad track and bridge maintenance and repair. A standard section on the railroad was a 10-mile length of track. (NRH.)

These early-day advertisements for real estate were truly a sign of the times. Very few people lived in the Oceano area during this time and beachfront lots sold for only $50 each. Those same lots are very expensive today, due to beach proximity and limited supply. (ODA.)

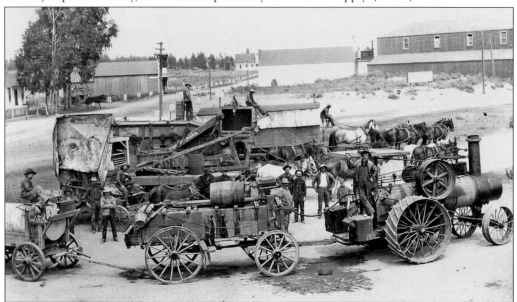

Jim Fisk's threshing team helped in a massive cleanup project after a big flood in Oceano in 1909. This was during a transition into the era of steam power, with a steam-powered tractor working alongside horse-drawn equipment. The view is looking east from the west side of Highway 1, just south of the intersection of Ocean Street and Highway 1. The Open Door Church is seen in the distance. (Photograph by Virgil Hodges; courtesy of Bennett-Loomis Archives.)

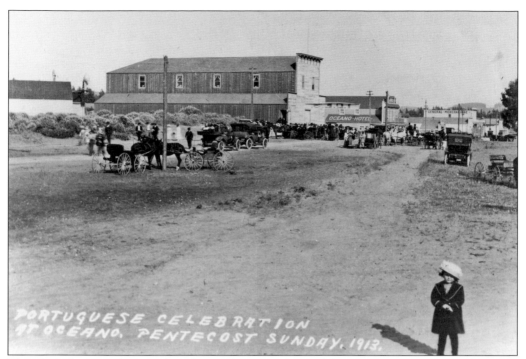

This 1913 photograph was taken during the Portuguese celebration on Pentecost Sunday. This view is downtown Oceano, looking east across present-day Highway 1. The large building in the center was a livery stable, with dance hall above, and at one time it was the Oceano Warehouse Company. Note the equal mix of horse-drawn wagons and automobiles. (Photograph by Virgil Hodges; courtesy of Bennett Loomis Archives.)

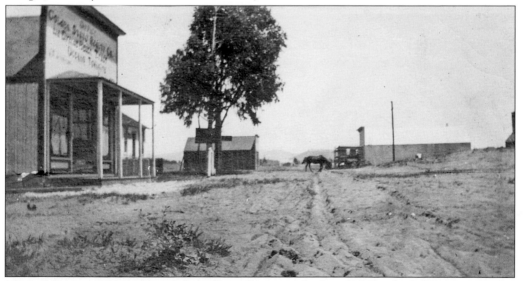

The building on the immediate left on Ocean Street was built in 1905 by the Golden State Realty Company to be used as the sales office for the La Grande tract that was in the dunes south of Oceano. On the right is the Halcyon Press building, which originally served as a store and then a movie theater. A horse is enjoying the weeds in the middle of the street. (Photograph by D. C. Gale; courtesy of ODA.)

This photograph, taken in the 1970s, shows the building that was the Beckett-Frakes General Store. The building later served as Oceano's first movie theater. The first movie shown in this theater in 1925 was a silent movie, *The Devil's Ride.*" Around 1929, the building was occupied by the Halcyon Press (which had moved from Halcyon into Oceano). This printing business was run by Lillian Harbison and her husband. (ODA.)

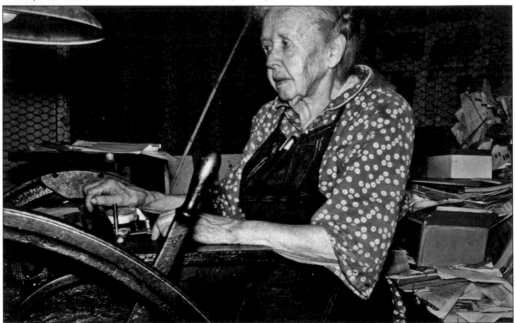

After the operation was relocated to Oceano, the name of the business was changed to the Oceano Print Shop. The shop published a number of books, including some by Ella Young and dunite Hugo Seelig. Lillian Harbison continued working in the printing business until she was in her nineties and is seen here with her printing press around 1962. (Courtesy of Peggy Weedon.)

T. V. Wheeler was born in Middleton, England, in 1861 and migrated with his family to Canada as a child. He later met and married Emma Jane in Canada, and they moved to Oceano in 1896. That same year, they established Oceano's first general store. Their store became one of the two economic centers of town, with the other being the depot. (ODA.)

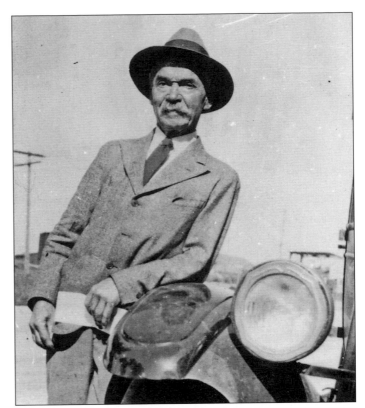

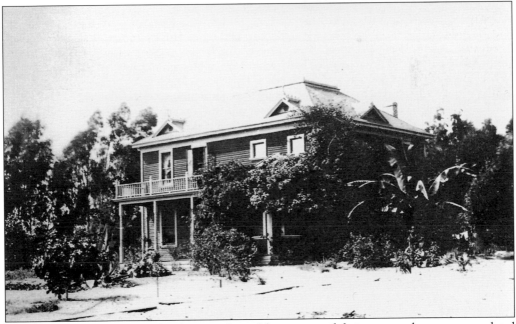

It is believed the Wheelers lived in the upper floor of their store until their two-story home was completed in 1902 to 1903. Their home was in the approximate center of a 1.12-acre parcel on the southwest corner of Wilmar Avenue and Seventeenth Street landscaped with palm, guava, and eucalyptus trees. A well with a pump house once provided water to this section of Oceano. (ODA.)

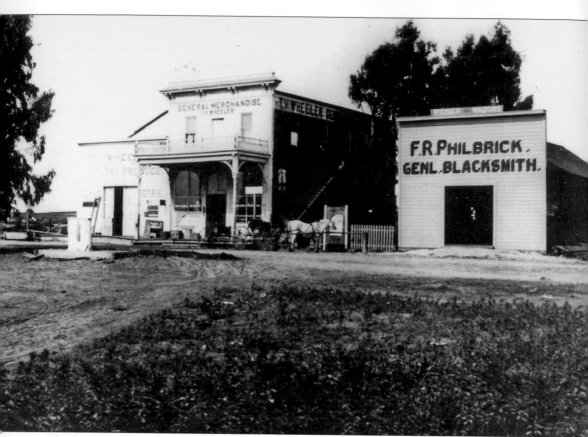

The first post office in Oceano was in the Beckett real estate office on the east side of Highway 1, between Paso Robles Street and Ocean Street. The second post office was later established in the lower part of the Wheeler store building in 1895. Although not the first postmaster, T. V. Wheeler served in that position for over 30 years. This view is looking east across Highway 1. The Wheeler store and Philbrick's Blacksmith Shop were located just north from where Highway 1 makes a sharp bend to the left as it turns east toward the Nipomo Mesa. (Photograph by Virgil Hodges; courtesy of ODA).

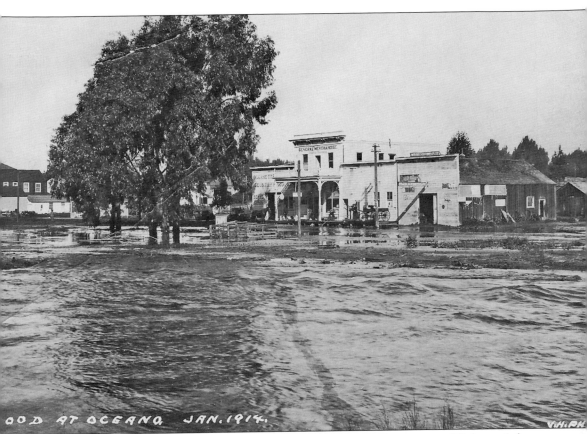

OOD AT OCEANO JAN. 1914.

This photograph taken by Virgil Hodges in 1914 is looking northeast across Highway 1 from between Beach Street and just north of where Highway 1 curves sharply to the east. The T. V. Wheeler General Merchandise Store is on the left, and Philbrick's Blacksmith Shop is on the right. The card was mailed January 29, 1914, by T. V. Wheeler (with a 1¢ stamp) to a recipient in Fresno. Wheeler wrote on the back of the card, "Worst flood ever. Another 100 feet washed out opposite our store. Iron bridge washed out at Arroyo. Your land was covered, but do not think it was much hurt." (Photograph by Virgil Hodges; courtesy of HEG.)

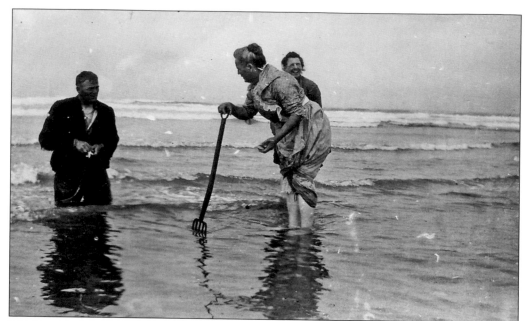

J. E. Parrish; his sister Margaret; and his wife, Mary, are digging for clams on Oceano Beach in 1915. Parrish is holding a fishing line that has been wrapped around Margaret to hold her long dress up out of the surf so she can dig for clams. Margaret is somewhat successful and is shown holding up a freshly dug clam. (HEG.)

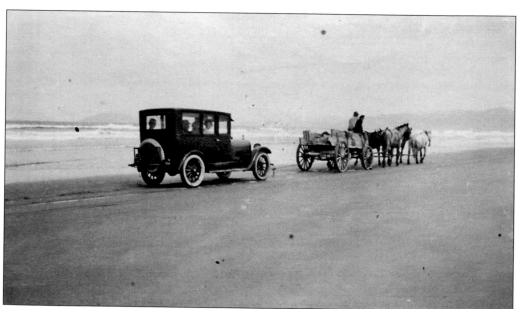

Seen here is J. E. Parrish in his horse-drawn wagon, pulling the Parrish family automobile down the beach toward Oceano in the early 1920s. Early-day automobiles were not always that reliable and would sometimes have problems starting because of the damp coastal weather. (HEG.)

Two

THE SOUTHERN PACIFIC
RAILROAD AND DEPOT

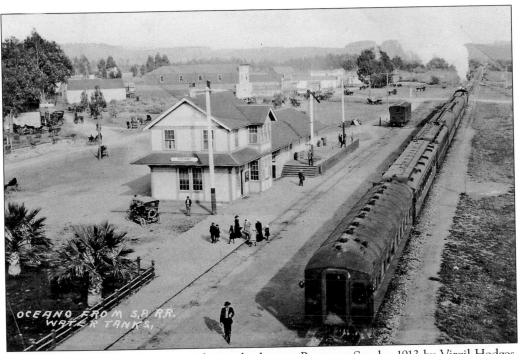

This postcard photograph was one of several taken on Pentecost Sunday 1913 by Virgil Hodges. The view looks southeast from the top of one of the water tanks that were used to fill steam locomotives. Highway 1 is on the left, and Beach Street crosses just in front of the locomotive. The age of the automobile has arrived but just barely. Over a dozen horse-drawn carriages can be seen on the streets of Oceano in this photograph. (Photograph by Virgil Hodges; courtesy of the Bennett-Loomis Archives.)

A northbound steam train is stopped on the main line at the Oceano depot in the 1920s. The elevated water tanks seen on the right were made of redwood. The tanks were used to fill the water tenders that were pulled behind steam locomotives during this time period. It is likely the engine was taking on water when this photograph was taken. (ODA.)

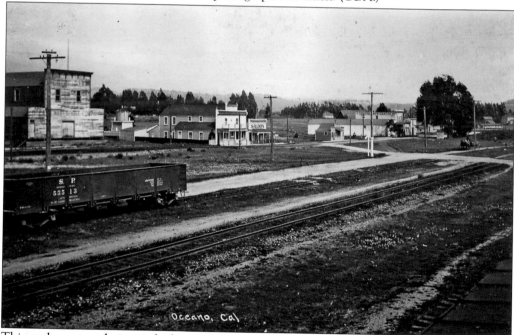

This early postcard view is looking southeast toward the Beach Street railroad crossing. The building on the left is the Oceano Warehouse Company. The building in the center is the Oceano (Righetti) Hotel and Saloon. Left of the large eucalyptus tree is the T.V. Wheeler store, which was torn down in the 1940s. A horse and wagon is just below the large tree, which was cut down in May 2010. (Photograph by Virgil Hodges; courtesy of ODA.)

Mary, Georgina, and Margaret Annecchini are standing here in front of the section foreman home, July 27, 1940. These girls are the daughters of Elsie and Nick Annecchini Sr., who came to Oceano in 1935. Their home was located just south of the present location of the Oceano depot, where Paso Robles Street intersects Highway 1. Nick was section foreman for the railroad for 18 years, retiring in 1950. (Courtesy of Georgina Annecchini Silva.)

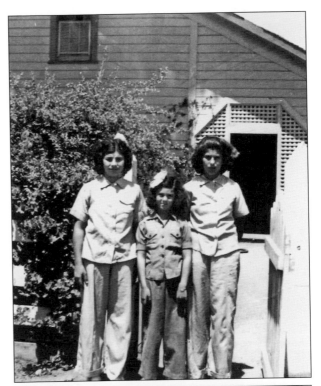

Halloween was a big event in Oceano. All the schoolchildren would dress up and parade from the school down through Front Street. Prizes were then given for the best costumes. Seen here in 1946 are, from left to right, unidentified, Virginia Murray, Charlotte Bray, Margie Bandurraga, and Sarah (Betty) Munro, daughter of depot agent Charles Munro. (ODA.)

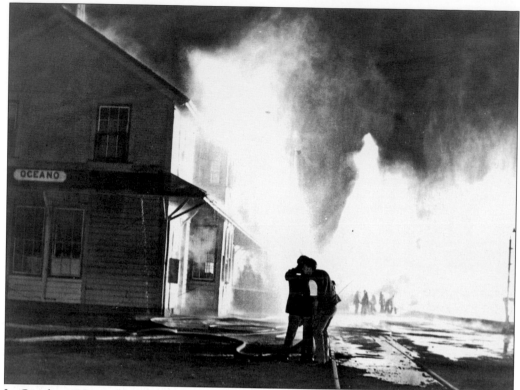

In October 1971, a disastrous fire destroyed the original Southern Pacific Milling Company, which was being used by the General Box Distributors for manufacturing produce boxes. The depot sat directly across the tracks and came close to being destroyed. This fire was the worst one to hit Oceano since 1903, when the original depot burned to the ground. (Photograph by Doug Zardeneta; courtesy of ODA.)

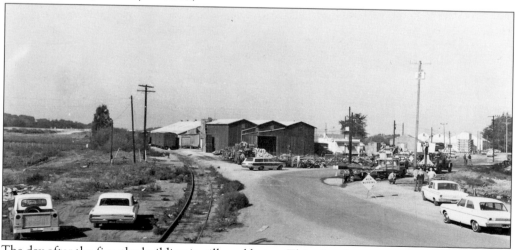

The day after the fire, the building is still smoldering. This view faces west on Beach Street from the railroad tracks. The three-roofed building in the center is the Southern Pacific Warehouse building, which was constructed over 100 years ago. This is the only surviving Southern Pacific building besides the depot and it is still there. The tracks seen here originally ran to the ocean but have since been removed. (ODA.)

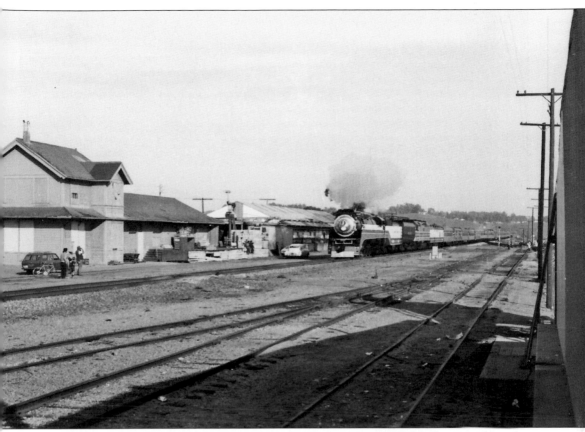

The Southern Pacific "Daylight" steam locomotive No. 4449 is shown heading north at the Oceano depot in April 1977. The engine is returning to its home base in Portland, Oregon, after touring the southern United States pulling the American Freedom Train for the 1976 American Bicentennial Celebration. The depot is closed and boarded up at this time, with the semaphore signal removed. (Photograph by Harold E. Guiton; courtesy of HEG.)

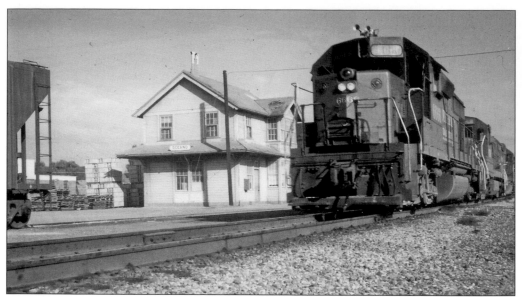

The last regular steam locomotive came through Oceano in 1954, ending the age of steam power on the Southern Pacific Coast Line. While many people missed the old steam locomotives, diesel power was simply much more efficient in terms of power, maintenance, and fuel costs. This photograph of a diesel engine heading north at the Oceano depot was taken before 1973, when the depot was no longer open for business. (ODA.)

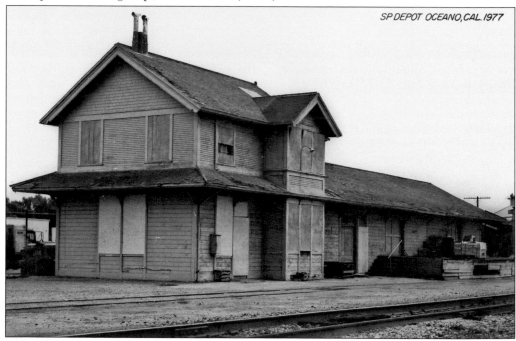

This postcard view shows the Oceano depot in 1977, boarded up and awaiting the move in 1978 to its new location .25 miles north. The depot was closed August 8, 1973, acquired by Phelan and Taylor Produce Company, used for a short time, and then sold to the Oceano Improvement Association (OIA) for a token $1 by Edwin M. Taylor. The Oceano depot is one of the few remaining type 22 depots on the California Coast. (Courtesy of Betty Cary.)

Three

THE OCEANO PAVILION AND PIER

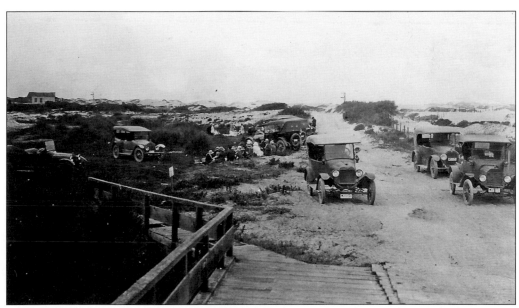

In the early days, Pier Avenue was where Airpark Bridge is today. This was the only bridge crossing the lagoon at this time, and this road was the only one that went across the lagoon and all the way to the beach. The road turns left in the distance (north) as it intersects the place where a new Pier Avenue, one that came across the lagoon, would be constructed in 1929. The store seen on the left side of this photograph can also be seen on pages 29 and 30. (HEG.)

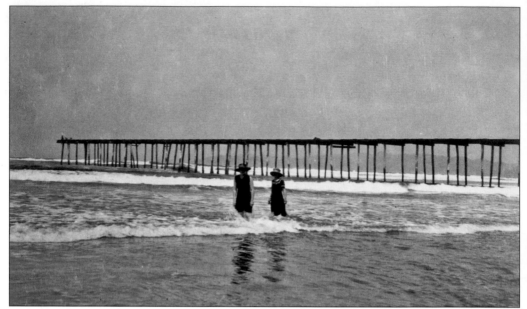

Lena Parrish (left) and Reeta Parrish enjoy the ocean south of the Oceano pier in the 1910s. The 1,000-foot pier was constructed at the end of present-day Pier Avenue around 1908 using a mule-driven pile driver. As with many of the piers on the Central Coast, the pilings for the Oceano pier were brought from the large forests of eucalyptus trees that had been planted on the Nipomo Mesa. (HEG.)

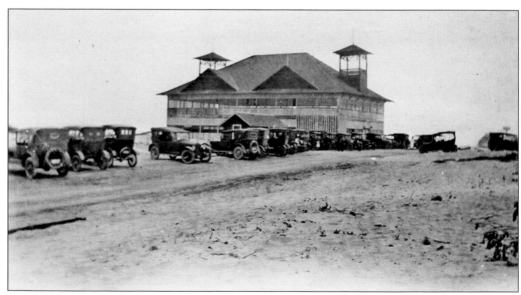

This photograph of the Oceano pavilion in the early 1920s is looking toward the beach, with Pier Avenue in the foreground. The two gazebos on the roof of the pavilion were removed after being in use for only a few years. Of the four pavilions on the Central Coast, this one had the longest life. When it was torn down in 1961, it marked the end of the dance hall era on the Central Coast. (HEG.)

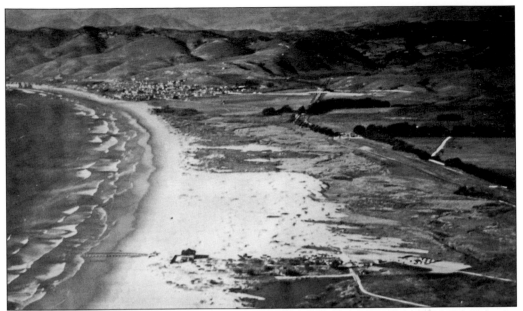

This early-day aerial photograph was taken between 1925 and 1927, looking north along the beach. The Oceano pavilion and pier are at lower left, with the Oceano Beach Auto Court on the lower right. The city of Grover Beach is right of center, and Pismo Beach is above the open area of sand dunes with the Santa Lucia range in the distance. (HEG.)

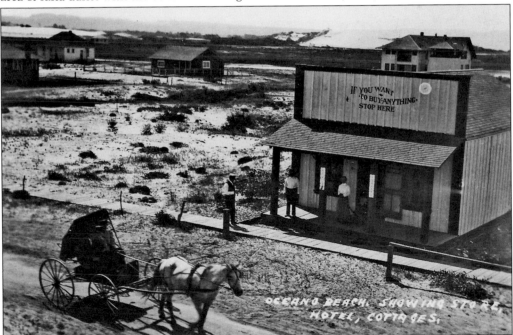

This Oceano Beach postcard photograph was taken in the early 1920s from the north side of Pier Avenue, looking south. Two people in a horse-drawn carriage are heading toward the beach. Note the extension of the wooden boardwalk that ran to the beach during those days. Seen behind the store is the Oceano Hotel (the third Hotel to bear that name), which also served as a Buddhist monastery in 1914. (Photograph by Virgil Hodges; courtesy of Bennett-Loomis Archives.)

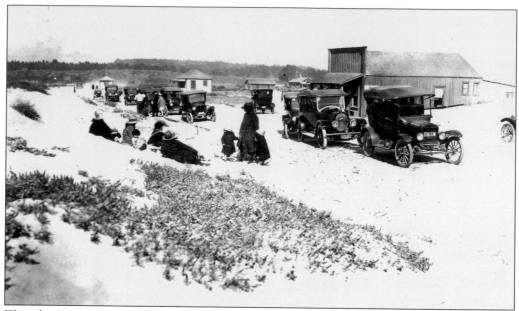

This photograph was taken in the 1920s looking east from the present-day beach parking lot on Pier Avenue. Oceano at this time only had streets of sand, making it easy for early-day automobiles to get stuck just driving around town. The building on the right served as a store for many years. The sign above the awning reads, "If you want to buy anything stop here." (HEG.)

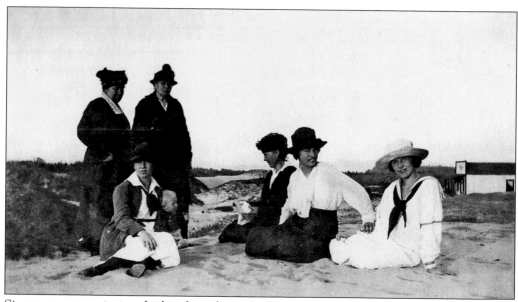

Six women are enjoying the beach at the end of Pier Avenue in the 1920s. Pier Avenue was a main thoroughfare at this time but remained a sandy street. The store on the right is the same one with a false front seen in the two previous photographs. Second from the left is Lena Parrish. Second from the right is Reeta Parrish of Arroyo Grande. (HEG.)

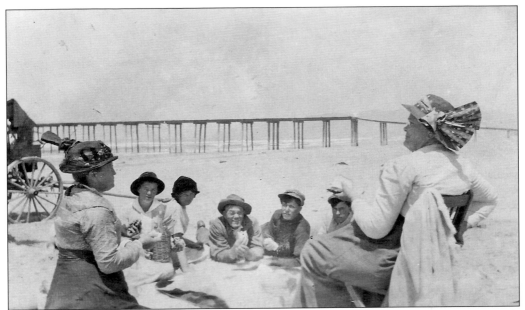

Arroyo Grande Valley rancher J. E. Parrish is pictured here around 1908 with his family just south of the Oceano pier. From left to right are Meg, unidentified, Lena, Parrish, Herman, Everett, and Sarah Parrish. This photograph was taken before the hand railings had been installed on the sides of the Oceano pier. Note the carriage on the far left. (Photograph by Reeta Parrish; courtesy of HEG.)

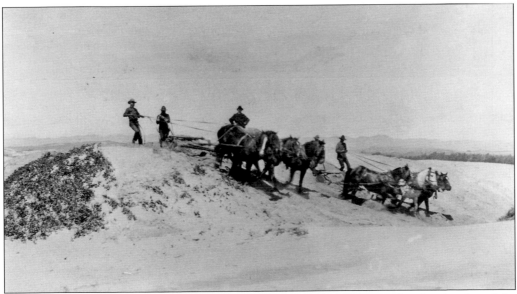

Three-horse teams were used in the early days for pulling these "Fresno plows" to level sand for construction in the area of Pier Avenue and Strand Way. Two teams are seen here working side-by-side. The on-going battle to keep streets clear of wind-blown sand near the beach areas has been relentless and continues to this day. (HEG.)

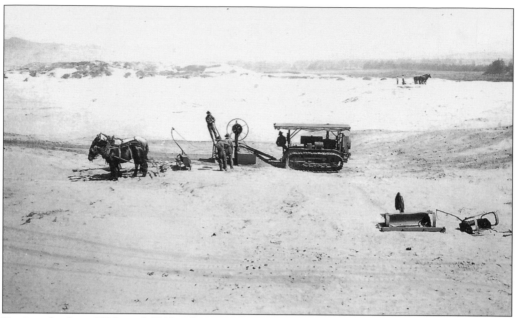

During the late 1920s and 1930s, there were not always enough mechanical tractors available for large sand-moving projects in the beach area. At these times, a blend of mechanical and horse-drawn power could be seen pulling plows to level the sand. A caterpillar tractor is seen here working with a horse-drawn plow. Another horse-drawn plow can be seen working in the distance. (HEG.)

This view is looking west toward the beach in 1942, with Lakeside Avenue in the foreground and Pier Avenue on the right. The building was a private residence, and in 1983 it became the Oceano Beach Fish and Chips, a popular seafood restaurant owned and operated by Armand and Hertha Carpentier, assisted by other family members. (Courtesy of Altman family.)

Four

CELERY, THE DUNITES, BUSINESS, AND THE AIRPORT

The Oceano Water Company is seen here in the 1960s. The right half of this building was once a "tank house" that held a small water tank for Oceano with the four corners sloping in to hold up the tank. The left half was added onto the tank house in the early 1950s. When this photograph was taken, the top story was a bedroom with stairs going up to it on the east side of the building. The building was torn down in 1979. (HEG.)

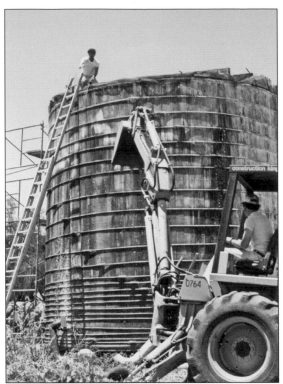

This water tank used later on by the Oceano Water Company was made of redwood. It was 22 feet high and held 50,000 gallons of water. By the 1970s, it no longer held enough storage capacity and is shown here being torn down in 1979 to be replaced with a 1-million-gallon storage tank. When the old redwood tank was torn down, a beautiful staghorn fern was found inside it, growing out of one of the 4-inch-by-4-inch timbers that braced the roof. (HEG.)

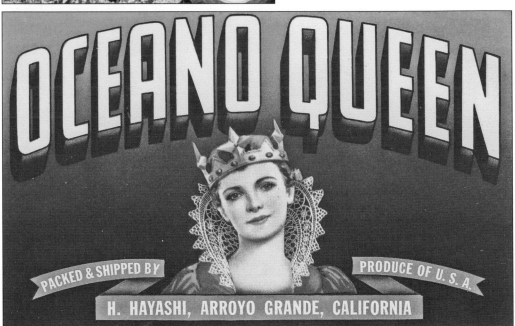

The soil and climate in Oceano was perfect for growing celery, and for many years it was one of the main crops shipped from the area. Celery remained a mainstay for farmers until the 1970s, when a mysterious blight devastated it. H. Hayashi's name on this Oceano Queen produce label reflects his part in the creation of the Pismo-Oceano Vegetable Exchange (POVE) in 1946. (Courtesy of Ralph Beck.)

Phelan and Taylor Produce Company was a partnership established in 1954 between Edwin M. Taylor and Cyril A. Phelan. In a 1991 *Times Press Recorder* article, John M. Taylor was quoted as saying, "After the war, this valley became nationally known for its celery. My dad built his business on it." John Taylor became president of the company in 1982 after his family bought out Cyril Phelan. (Courtesy of Ralph Beck.)

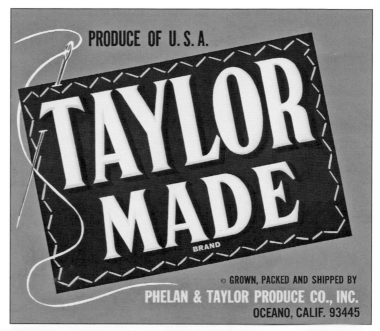

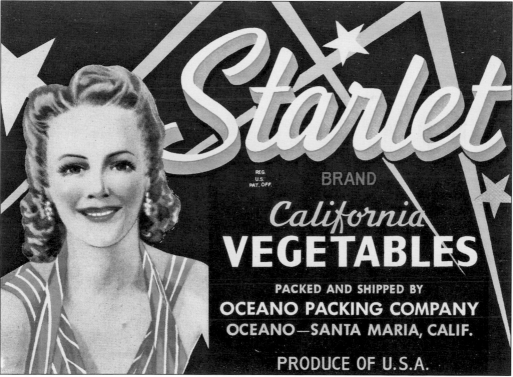

The Starlet label was one of several used by the Oceano Packing Company, which was founded in 1945. During the years of the Celery Festival, celery was still an important crop in Oceano. Station agent Carl Brumfield's weekly report showed that during the six days ending on Saturday July 24, 1954, a total of 112 boxcars of celery were shipped out of Oceano, with an average shipment of 17 cars a day for the entire week. (Courtesy of Ralph Beck.)

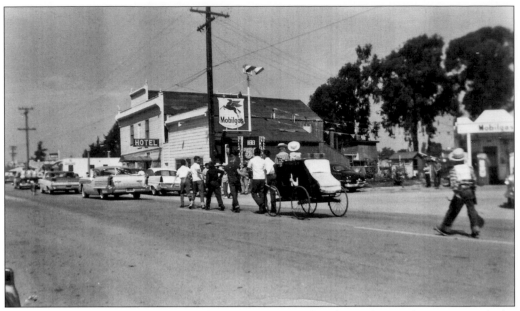

The Oceano Women's Club sponsored the Celery Festival each year from 1951 to 1960, with the Oceano Elementary School heading the parades. In this 1958 Celery Festival parade are "horses" David Fortner, Billy Dieball, Herman Hawley, James Wallace, Jimmy Lietzke and Walter Hanby pulling the stagecoach driven by Jimmy Wright and Bobbie Dieball. Passengers Roberta Dieball and Geraldine Wright look out the windows as they head down Front Street. Oceano Hotel can be seen on the right. (Courtesy of Dolores Cardoza.)

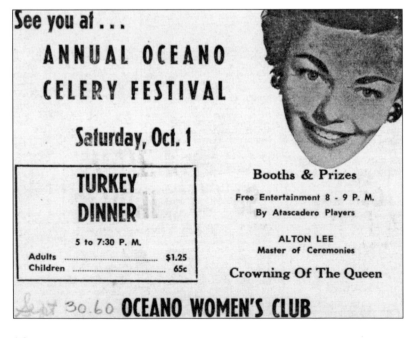

See you at . . .

ANNUAL OCEANO CELERY FESTIVAL

Saturday, Oct. 1

TURKEY DINNER

5 to 7:30 P. M.

Adults $1.25
Children 65c

Booths & Prizes

Free Entertainment 8 - 9 P. M.
By Atascadero Players

ALTON LEE
Master of Ceremonies

Crowning Of The Queen

30.60 **OCEANO WOMEN'S CLUB**

The election of the celery queen was based on the number of Celery Festival turkey dinner tickets each celery queen candidate sold that year. The dinner included music, entertainment, booths, prizes, and the crowning of the queen. The celery queen for 1960 was Dixie Banta. (Courtesy of Oceano Women's Club.)

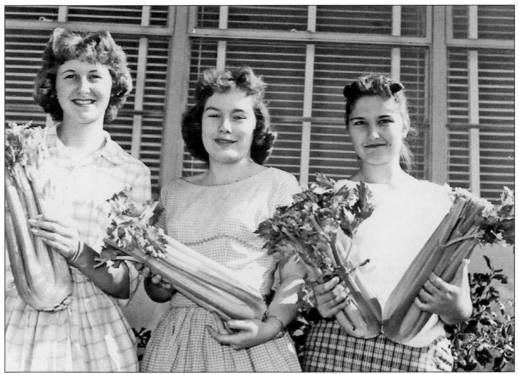

These three attractive girls from Arroyo Grande High School holding stalks of celery are candidates for the 1959 celery queen. The queen will reign over a variety of activities during the Celery Festival at the Oceano Women's Club. Left to right are Beverly Richards, Sue Hutton, and Ann Welch. (Photograph by Dennerlein; courtesy of ODA.)

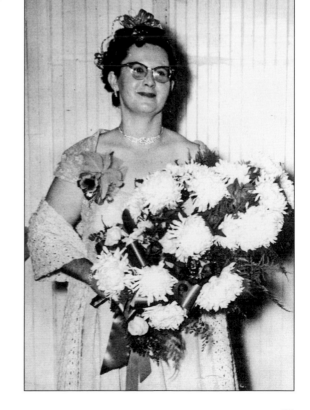

Pauline Austin was crowned the 1954 celery queen. Pauline and her husband, Howard, successfully ran the small market and Shell gasoline station on the corner of Highway 1 and Paso Robles Street for many years. (Courtesy of Howard Austin.)

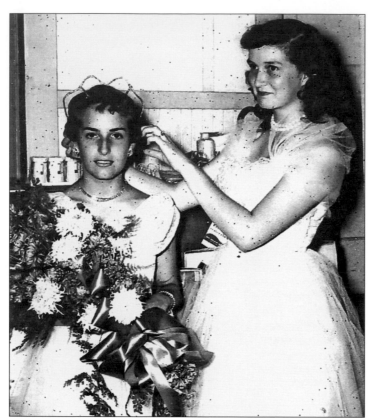

Shown here is Janet Godfrey Estes, 1955 celery queen, crowning Gerry Wilson of Grover City as the 1956 celery queen. (Courtesy of *Times Press Recorder.*)

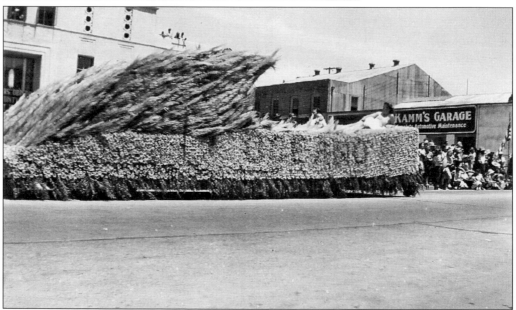

The Oceano Elementary School marching band, the women's club, and local businesses participated almost every year in the San Luis Obispo La Fiesta parade. This Oceano Ice Company entry in the 1949 parade was a float that was made using ice plant flowers, celery, ferns, pampas grass, and flowers from the yards of local residents. (ODA.)

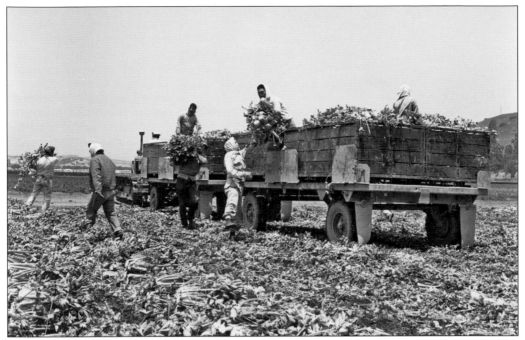

Produce during the 1960s was handpicked by field workers and loaded onto trailers pulled by tractors. The trailers were then taken to the large packinghouses next to the railroad tracks, packed into shipping crates, iced, and then loaded into insulated boxcars for shipping. After 1976, the produce was packed directly into boxes in the field and then shipped by truck. (Courtesy of *Times Press Recorder.*)

Dr. Catherine T. Nimmo was born in 1887 in Rotterdam, Netherlands. She became a registered nurse and a doctor of chiropractic medicine before coming to Oceano in 1948. She was a vegetarian and a founder of the first vegan society in the United States. Dr. Nimmo cared for the people and animals of Oceano for many years and was an honorary lifetime member of the Humane Society. She passed away in 1985 at the age of 97. (Courtesy of Peggy Weedon.)

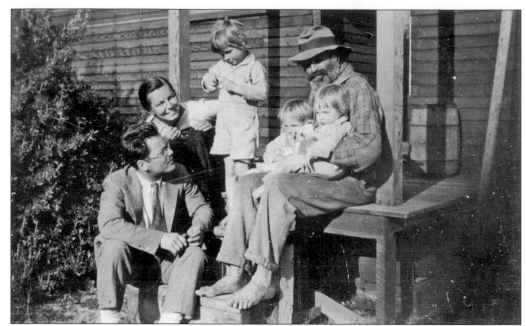

From left to right, Dr. Rudolf W. Gerber; his wife, Catherine; and their girls, Barbara, Lesley, and Catherine, are pictured with dunite poet and philosopher Hugo Seelig in 1931. Oceano's Dr. Gerber was a significant historian of the Dunites, his friends, passing on their stories with speeches, writings, and interviews for local organizations, the state park, Cal Poly University, and historical authors. He was intent that Dunite history not be lost and gave freely of his knowledge and photographs. (Courtesy of Gerber Family Papers.)

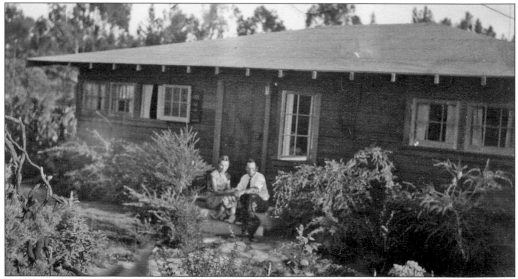

Dr. Gerber built this home on Paso Robles Street in 1930, utilizing many classic features of craftsman bungalow–style architecture. This included multipaned windows, an overhanging roof, a rock chimney, and high interior ceilings. The Gerbers' garden and the self-sustenance of their lifestyle were also concepts of the craftsman philosophy. This photograph of Catherine and Dr. Gerber was taken around 1934, when the Sri Meher Baba visited the Gerber home. (Courtesy of Gerber Family Papers.)

Catherine and Dr. Rudolf W. Gerber are pictured at their daughter Lesley's garden wedding to Victor P. Benn in September 1947. Over 100 friends and relatives attended from near and far. Silk was not available during and immediately after the war, so the bride wore a dress that was beautifully made from parachute silk by talented seamstress Annie Altamirano, a nearby neighbor and friend. (Courtesy of Gerber Family Papers.)

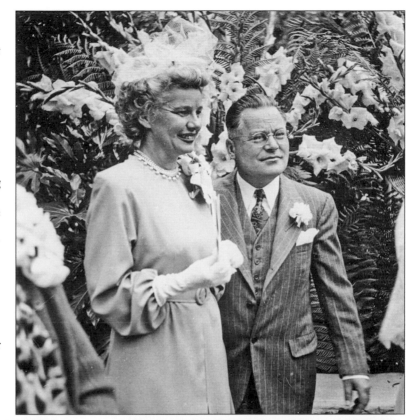

After the original Oceano depot burned in 1903, a new station was quickly put in its place the following year. When that depot was moved in 1978 to its present location, the foundation bricks were salvaged by the OIA volunteers and stored on the depot grounds. In 2005, Tye Lovern made planter boxes out of them for the Dr. Rudolf W. Gerber Memorial Park roses. (ODA.)

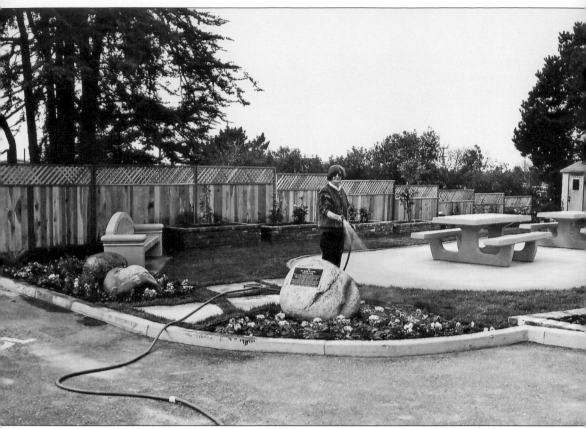

Dr. Rudolf W. Gerber lived in Oceano from 1930 until his death in 1992. He was very well liked and many described him as "Oceano's own country doctor." Community leader Harold Guiton had always planned to do something special for Dr. Gerber. After Harold passed away in 2001, the Oceano depot Association constructed this small memorial park behind the depot and dedicated it to Dr. Gerber in October 2005. The stone in the center has a plaque honoring Dr. Gerber. The brick planter boxes for roses, made from the bricks from the original platform of Oceano's first depot, are now in place. Glenda Guiton is shown here watering the grass prior to the sprinkler system being installed. (Photograph by Linda Austin; courtesy of ODA.)

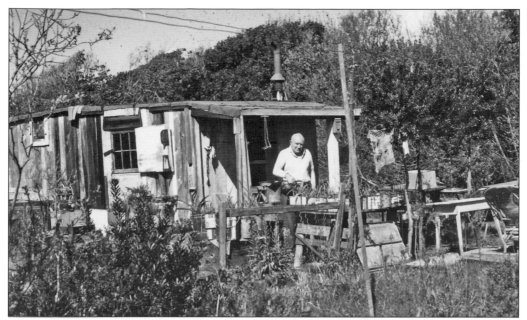

Bert Schievink was one of the people living in the dunes south of Oceano known locally as the Dunites. Bert lived in the dunes for 34 years, from 1940 until his death in 1974. As a part-time caretaker of weekend homes in town, he enjoyed having a lot of free time and living alone as a hermit. (Photograph by Harold E. Guiton; courtesy of HEG.)

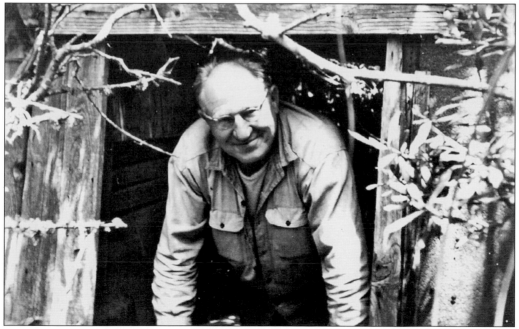

Bert Schievink is shown here in 1972 at the abandoned cabin of Dunite Francis Prior. Bert was very studious and spent much of his time reading newspapers and books of the world. He was also very passionate about Astrology, studying astrology and teaching it to others. He enjoyed doing horoscope charts and did many of them for people living in the dunes and in Oceano. (Photograph by Harold E. Guiton; courtesy of HEG.)

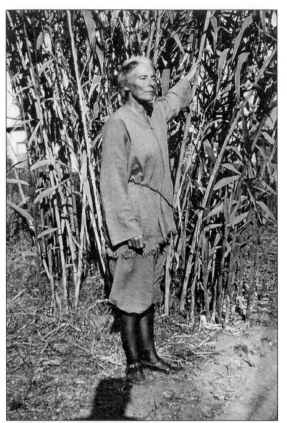

Ella Young came from Ireland and wrote many books on Irish mythology and folklore. She moved to Oceano in her later years and was friends with many of the Dunites. She became the godmother of Moy Mell, a Dunite colony that flourished in the Oceano dunes during the 1930s and early 1940s. (Courtesy of Peggy Weedon.)

Ella Young's home on Paso Robles Street in the early 1960s was surrounded by a small forest of succulent plants. A sign above her door stated what she liked to call her home, Claun Ard, which translates to "sandy place" in Gaelic. Ella was highly attuned to nature spirits in the area and especially those who lived around her home. An unidentified woman is sitting on the left, with Peggy Weedon sitting on the right. (Photograph by Doug Weedon; courtesy of Peggy Weedon.)

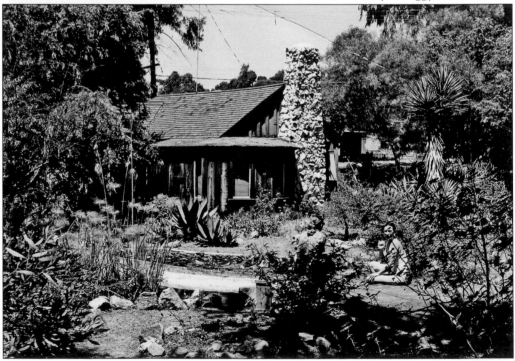

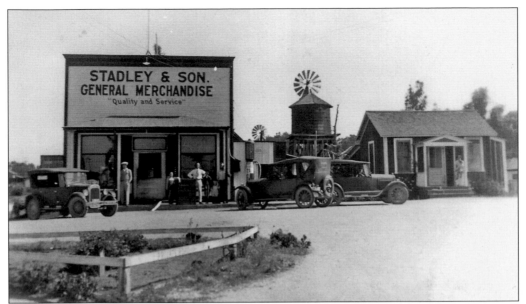

The Thomas Jefferson "T. J." Stadley family ran the Stadley and Son grocery store on Ocean Street in Oceano from 1927 to 1932. During that time, they came to know many of the Dunites who lived in the sand dunes just south of Oceano. The Dunites would often trade art and carvings for basic necessities needed for living in the dunes. Imogene Stadley Martin recently donated a carving done by Dunite Arthur Allman to the Oceano Depot Association. (Courtesy of Stadley family.)

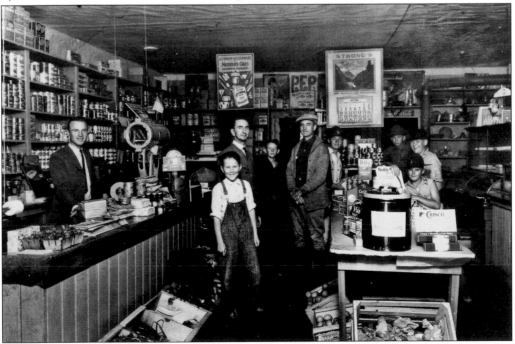

A typical day of business in the Stadley store is pictured here around 1929. Standing in front of the counter, behind his son Jimmy, is T. J. Stadley. Behind the counter is his other son, Carlisle. The other people in the store are customers or visitors to the store. In 1932, the Stadley store was sold to Carl Angello. (Courtesy of Stadley family.)

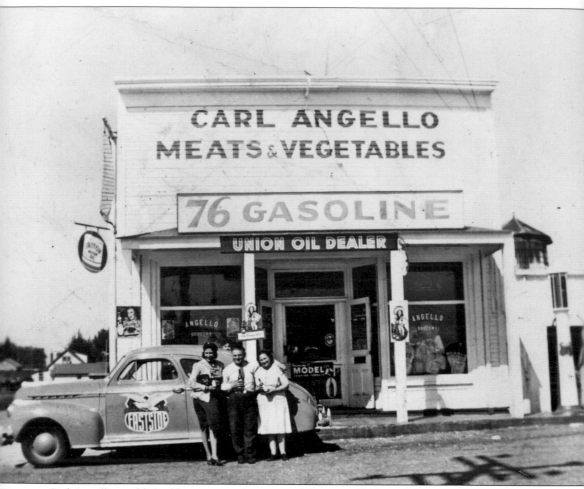

Carl Angello established his store on the corner of Ocean and Fifteenth Streets in 1932 and operated it until his retirement in 1962. This store was formerly occupied by La Grande real estate office, Cash Grocery, Sanford Grocery, and Stadley and Son. The gasoline dispenser with the glass top seen on the right had to have the fuel pumped up into it by hand. Graduated marks on the glass top allowed customers to verify how much gasoline they had purchased before it was allowed to flow by gravity into the tank of the automobile. This dispenser is now on display in the Oceano depot. In 1953, Carl's son Bill added on to the east end and established Bill's TV there from 1954 to 1968. Shown here in the 1940s are Carl (center) and Lena Angello (right) with a friend. The building was torn down in the 1990s. (Courtesy of Angello family.)

Carl Angello enjoyed custom calendars in his store that featured pretty girls. This 1948 Angello Grocery calendar is typical of the calendars that he had on display in his store. (Courtesy of Betty Angello.)

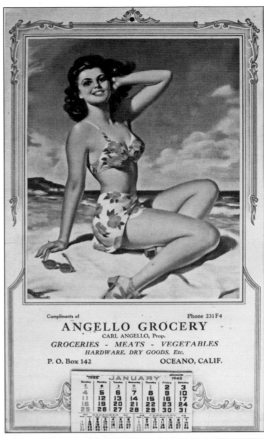

Paul "Bud" and Irene Sweeters are pictured at their filling station and garage on the corner of Thirteenth and Paso Robles Streets. Paul and Irene had owned a garage in Cambria before moving to Oceano. They purchased this garage in 1932 and operated it until 1975. The building is still standing. (Courtesy of Manuel Sebastian.)

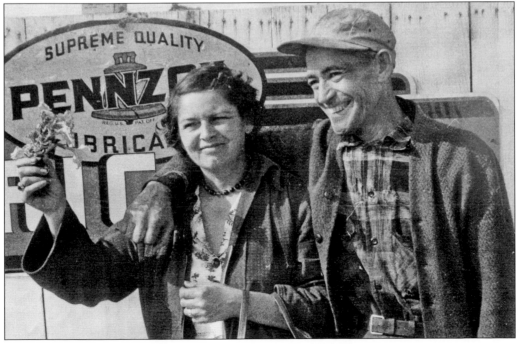

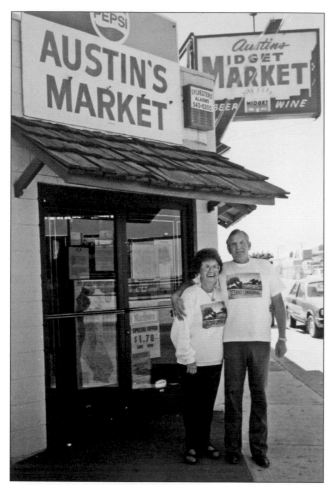

Howard and Pauline Austin opened Austin's Midget Market on Highway 1 and Paso Robles Street in 1960. In 1964, they took over the Shell station at that same location. The station was started by Pauline's father, R. B. Gatlin, in 1923 and may have been the first one in Oceano. Howard and Pauline are seen here in front of their store in 1993. The station was operated by the same family for over 70 years. (Courtesy of Howard Austin.)

Carl and Albert Beck established Beck Brothers Boat Shop in 1935 and began building boats in Oceano. The shop was within the narrow intersection of Highway 1 and Fourth Street. The house next to the shop was moved from Pismo when construction began on the shop. Carl served in World War II but resumed his boat-building business after returning from the service in 1945. (Courtesy of Geneva Beck.)

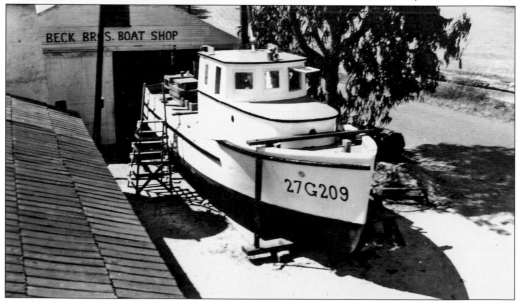

Carl Beck is seen here standing in front of one of the unfinished boats. The boat shop made three of these large fishing boats, the *Westwind* being the last one, which is still at Avila. The shop also made a number of smaller abalone boats. Beck Brothers published a brochure describing the features of the boats they built and about fishing in the area. (Courtesy of Geneva Beck.)

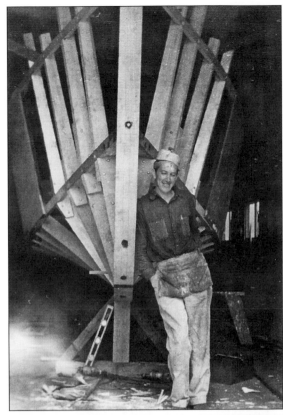

Louise Beck, Carl's mother, started making animal statues in Oceano in 1926. She created this cement deer entirely by hand using simple tools and without molds. She also made bear, antelope, horses, cows, swans, and lions. The antlers on her deer statues were made from deer she had hunted herself. Louise avidly hunted, fished, and trapped until she was in her eighties. (Courtesy of Geneva Beck.)

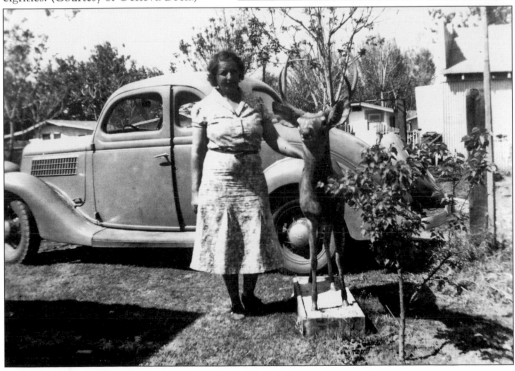

The Oceano Sand Company, located on the edge of the dunes south of Arroyo Grande Creek, was established in 1925 by Harold Guiton Sr. The high quality Oceano core sand was in fierce demand during World War II and was shipped by rail to foundries in Oakland and Los Angeles. Harold Guiton Jr. is seen here in the early 1960s on the tower that held dried sand. The Oceano Sand Company exists to this day. (HEG.)

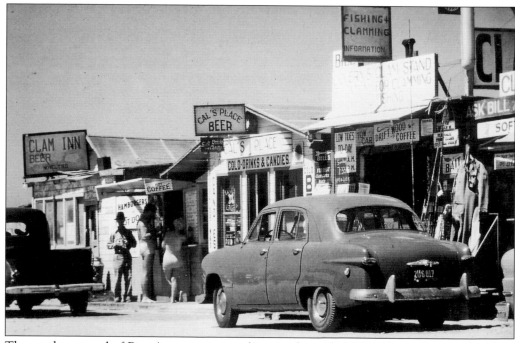

The northwest end of Pier Avenue was very busy in the early 1950s. Shown here is the Clam Inn, with beer and novelties; the hamburger stand, with hamburgers, hot dogs, soft drinks, and coffee (the "hot coffee" sign is now displayed in the depot boxcar); Cal's Place, with beer, cold drinks, and candies; and Bill Lovern's Clam Stand, with just about everything else that might possibly be needed. (ODA.)

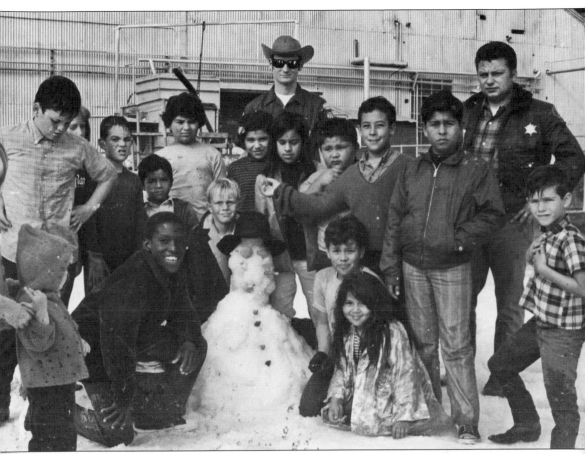

On December 20, 1969, an artificial snowstorm was enjoyed by the children of Oceano. Maynard Murray, the owner of the Oceano Ice Company, used 75 tons of snow ice to cover the company parking lot twice. A snowman contest was held with the following winners: ages 6 and under, Shelly Rede and Carlos Ramirez; ages 7–9, Pam Wiggins and Mike Mintz; and ages 10–12, Holly Thompson and Melvin Maybee. This community event was attended by 400 children and was sponsored by Boy Scout Troop No. 455, the sheriff's department, and the Oceano Ice Company. Helping to supervise is a law enforcement explorer, in the rear, and deputy sheriff Larry Austin, on the right. Next to him is Tracy Boyd (right). (Courtesy of *Times Press Recorder*.)

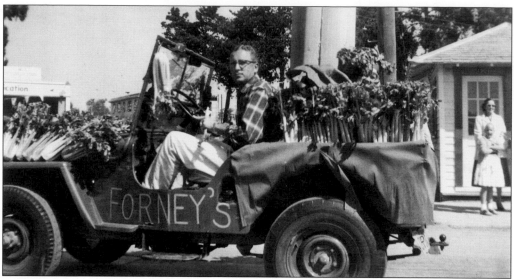

Forney Watson owned and operated Forney's Liquor on Front Street in Oceano from 1946 to 1969. Many businesses participated in the Celery Festival parade, and Forney's Jeep was an entry in 1958. The Jeep is being driven by Woody Lynn, and Brent Watson is in the back with a crown of celery on his head. (Courtesy of Dolores Cardoza.)

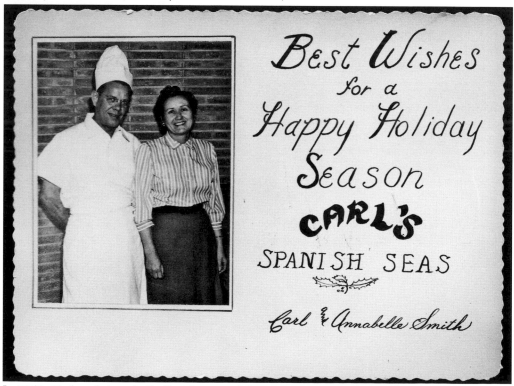

In 1954, Carl and Annabelle Smith opened their restaurant on the south side of Pier Avenue where the Elks Club is today. The restaurant featured a high fidelity sound system to pipe dinner music to all parts of the building and had a capacity of 160 people. Besides conventional entrees, they also featured Spanish and seafood meals. (HEG.)

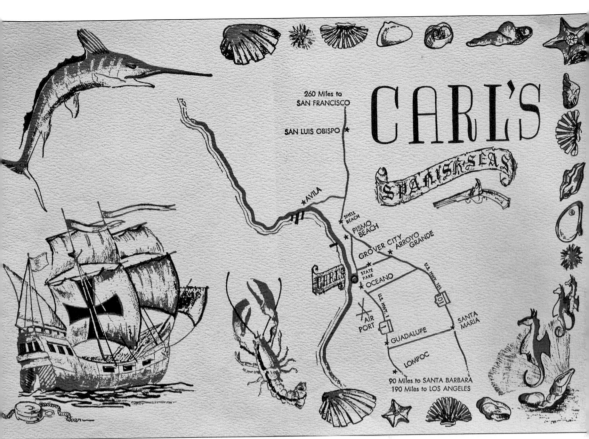

Carl's Spanish Seas was later moved to the corner of Highway 1 and Pier Avenue. In time, it was purchased by John Verdin, who named it Old Juan's Cantina, and it remains a popular restaurant today. This place mat shows the old location of the restaurant on the south side of Pier Avenue, prior to it being moved to where Old Juan's Cantina is today. (HEG.)

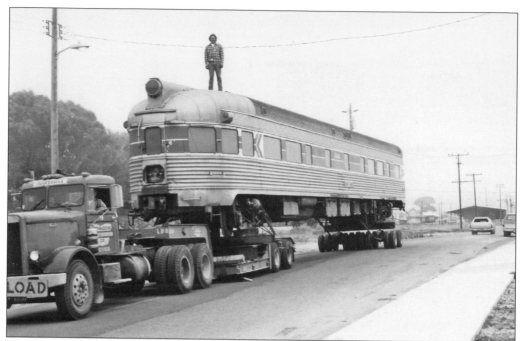

This 1947 lounge car, which once rolled on the famed Orange Blossom Special passenger train between New York and Miami, was brought to Oceano in 1977. The car is one of two cars that were brought to Oceano by ex-railroader Chic Sales. The two cars were coupled together and became part of The Oceano Railroad Company on Railroad Avenue. Today the restaurant is known as the Rock and Roll Diner. (Photograph by Harold E. Guiton; courtesy of HEG.)

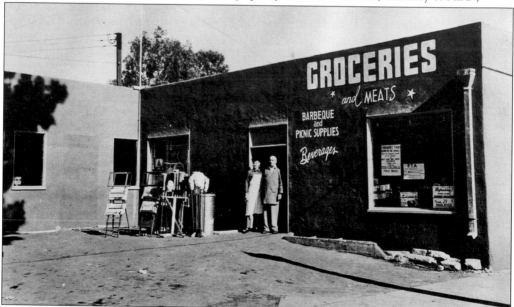

Emmett and Dorothy Montgomery are standing here in front of the market they built in 1935 on the southeast corner of Beach Street and Highway 1. During this time, the Montgomery's market also housed the Oceano Post Office, of which Dorothy was postmaster. La Tapatia Market is now at this location. (Courtesy of Janice Hilton.)

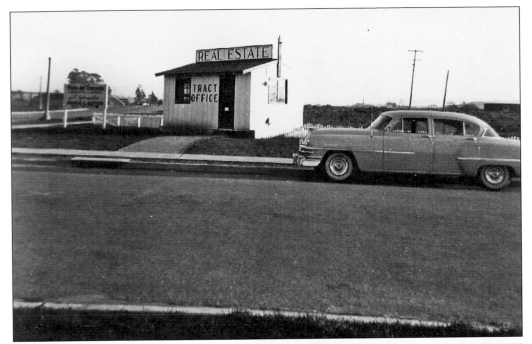

This is the second sales office used to promote the Vista Del Encanto subdivision. It sat on the opposite corner from Bill Wise's lighthouse-shaped sales office (present site of the Oceano Inn) on Pier Avenue and Highway 1. Vista Del Encanto, "the enchanted view," boasted curbs, gutters, sidewalks, and lampposts and overlooked a freshwater lagoon. This view is looking east with the Highway 1 overpass in the distance. (HEG.)

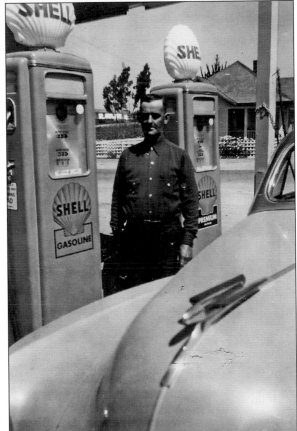

R. B. Gatlin is seen here standing in front of his Shell station and novelty shop on Highway 1. The Gatlin Shell station was established in 1923. The Sweeter home is across Paso Robles Street in the background. (Courtesy of Howard Austin.)

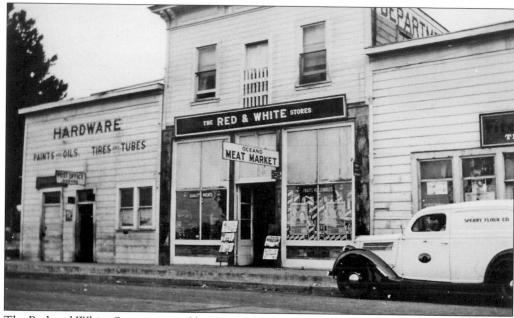

The Red and White Store operated by Emmett and Dorothy Montgomery was formerly the T. V. Wheeler Store, just south of the intersection of Beach Street and Highway 1. During this time, the hardware store on the left also served as the Oceano Post Office. The family lived upstairs and had a hole in the floor where a bucket attached to a rope could be lowered down to bring groceries upstairs. (Courtesy of Janice Hilton.)

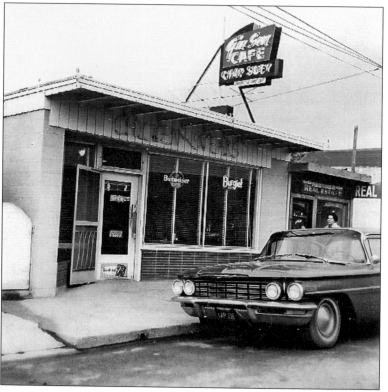

The Gin Sen Café was established by Shu Sen Gin in 1951 and specialized in Cantonese food. The restaurant was very popular with locals for over 40 years, until its closure in 2006. (ODA.)

Ashtrays from California's cafés and restaurants have become rare items since smoking in those establishments was banned. In 1990, San Luis Obispo became the first city in the world to ban indoor smoking at all public places, including bars and restaurants. It was not long after that before this ashtray from the Gin Sen Café in Oceano was out of service. (NRH.)

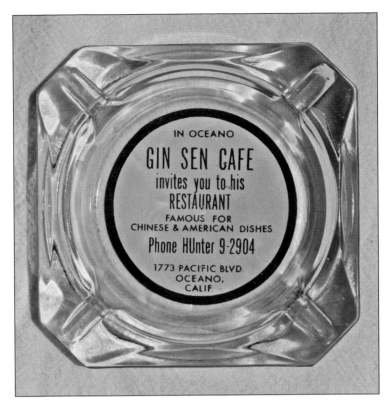

IN OCEANO

GIN SEN CAFE
invites you to his
RESTAURANT
FAMOUS FOR
CHINESE & AMERICAN DISHES
Phone HUnter 9-2904
1773 PACIFIC BLVD.
OCEANO,
CALIF.

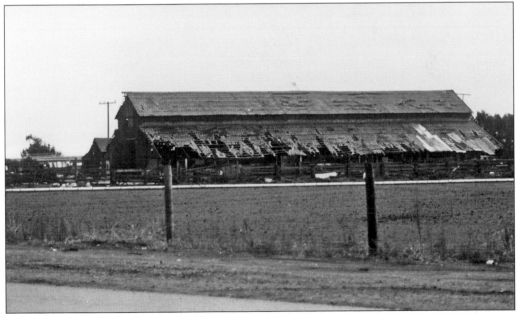

During the 1940s, the Dalessi barn housed a horse stable, held livestock auctions, had a snack bar, and was a favorite haunt of local children, who could ride a horse from there to Pismo for the day. During World War II, the coast guard used the barn to quarter their horses for patrolling the beach south of Oceano. The Dalessi barn was demolished in 1976 to make way for the Pike Lane Industrial Park. (Photograph by Harold E. Guiton; courtesy of HEG.)

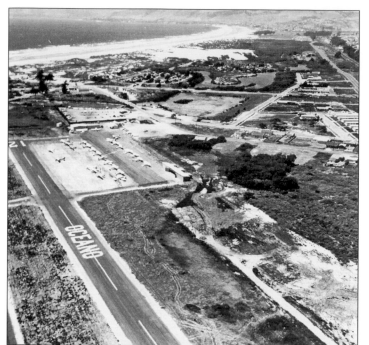

The sandy soil of the Oceano Airport was used for years by pilots for landing. In 1951, it became an official airport with a 2,300-foot paved runway. The first managers of the airport were Avery Blanchard and his family. Note the lagoon (center) and small dune complex advancing inland between Oceano and Grover Beach. This pilot's view of the airport was taken in 1965. (Courtesy of ODA.)

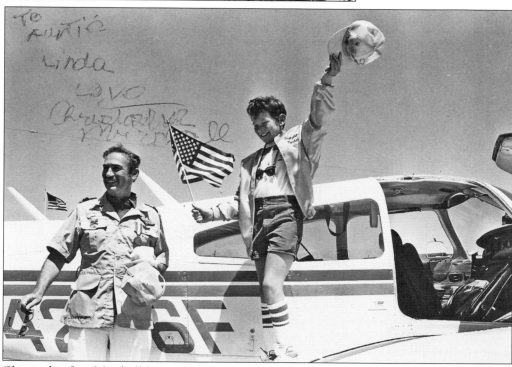

Christopher Lee Marshall learned to fly at an early age. In 1987, when he was 10 years old, he flew a single-engine plane from the Oceano Airport to Fort Lauderdale, Florida, becoming the youngest person ever to fly coast-to-coast across the United States. He was too young to obtain a pilot's license, so his instructor, Rowe Yates, rode along with him. This photograph was taken on his return to Oceano. (Courtesy of Linda Austin.)

Five

CHURCHES, SCHOOLS, AND VOLUNTEER ORGANIZATIONS

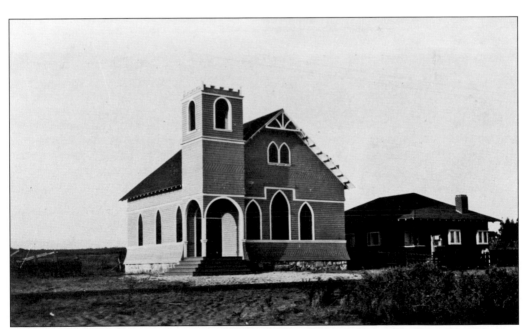

The Open Door Church on the corner of Nineteenth and Ocean Streets has been in continuous operation as a place of worship since November 1906. In 2006, the community held a celebration recognizing the historical significance of the church and its importance in the lives of the citizens of Oceano for the past 100 years. (Photograph by D.C. Gale; courtesy of ODA.)

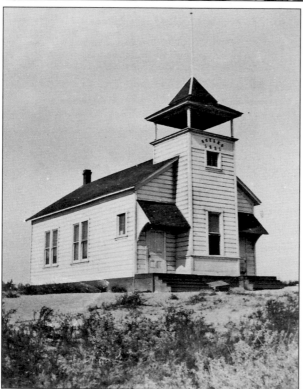

Rev. Robert J. Banker and his wife, Patsy, have been living in Oceano since 1960, and Bob has been pastor of the Open Door Church ever since. The bell of the church shook so hard during the earthquake of 2003, it came loose from its mounting. Rick Searcy and Reverend Banker remounted the bell and now it can be heard again, ringing every Sunday just a few minutes before the 11:00 a.m. service begins. (Courtesy of Rev. Bob Banker.)

This one-room schoolhouse located on Wilmar Avenue and Nineteenth Street was the first schoolhouse in Oceano. It housed grades one through eight, taught by just one teacher. The letters beneath the belfry read, "Oceano, 1901." The school was later enlarged; then in 1952, a newer school was completed on Seventeenth Street and Wilmar Avenue. (Courtesy of D. C. Gale.)

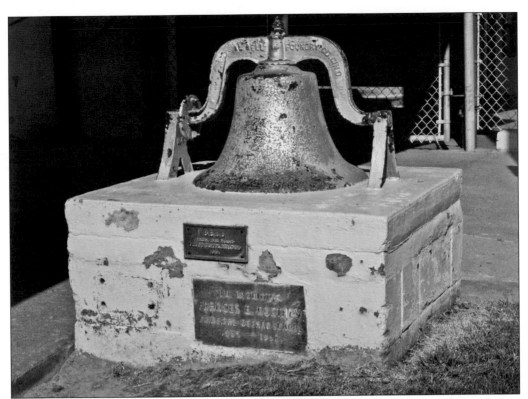

In 1956, the original bell in the belfry of Oceano's first schoolhouse was mounted near the entrance of present-day Oceano Elementary School. The upper plaque reads, "Bell / from the first Oceano School Building / 1901." The larger plaque below it reads, "In memory / Mrs. Frances E. Northey / Principal Oceano School / 1935–1952." (NRH.)

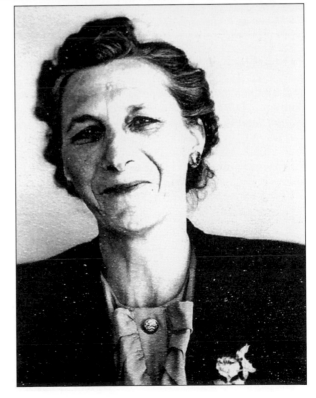

Frances Northey was a teacher at Oceano School for 6 years and was principal for 12 years. She and her husband, Otto, moved to Oceano in 1935 when she started teaching school. Everyone who went to school in Oceano during those years seemed to like and respect Frances Northey and likely remembers her with great fondness. (Courtesy of Lois Northey.)

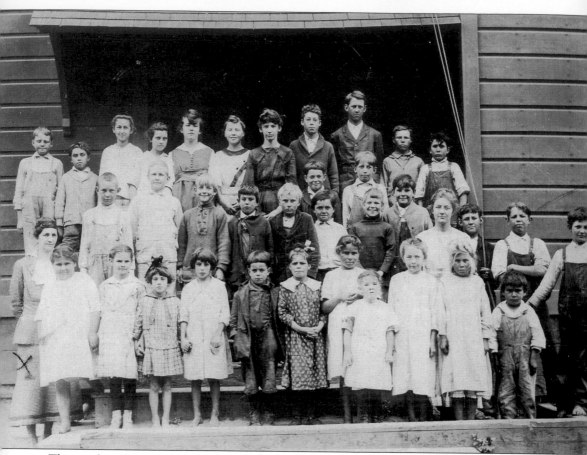

The combined grades of one through five were taught at the early Oceano School during the years 1920–1921. Shown here are, from left to right, (first row) Mrs. Childs (teacher of upper grades), Georgiana Brum, Louise Snippel, Anna Huber, Josefiline Huber, John Simpson, Rose Simpson, Mary Brum, ? Simpson, Venus Hector, Amelia Fhram, John Brum; (second row) Lloyd White, Russel Carter, Lincoln Whitcus, ? Huber, Walter Fladarn, Albert Simpson (between first and second row), Willard Lee (above first and second row), George Wheeler, Charles Galbraith, John Phipps, Miss Conrow (teacher of lower grades), Morris White, Thornton Lee, Frank Scolari; (third row) Frank Carter, Norman Philbrick, Dorothy Hector, Dell Philbrick, Thelma Lee, Martha Bardrick, Laura L. Lee, Eric Varian, Ormond White, Claude Bardrick, and Ernest Brum. (Courtesy of Karen Olney.)

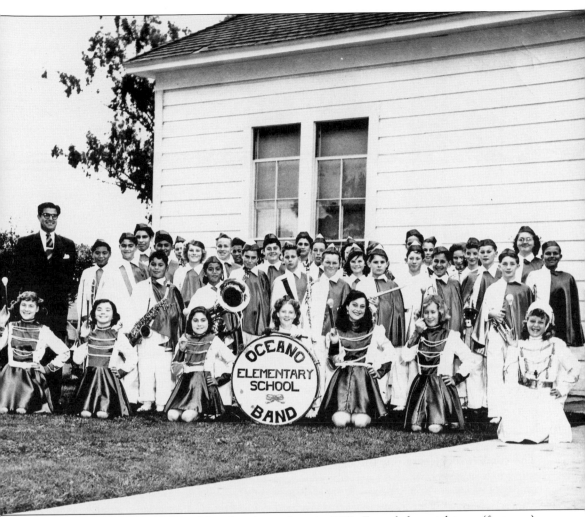

The Oceano Elementary School band is shown here in 1951. From left to right are (first row) Lila Kissler, Judy Rodgers, Linda Battles, Mary Ellen Caperton, unidentified, Jeanne Scott, Shirley Berning; (second row) director Marion Moreno, Jimmy Cabalas, Vincent Antonio, two unidentified, Charlotte Bray, Keith Wolfe, unidentified, Art Romero, Ellis Castner, Ronald Godfrey, Danny Messer; (third row) Richard Medina, Tommy Batula, Bobby Brannon, Dean Gregory, five unidentified, Harold Funston, Carolyn Bryant, Janet Godfrey, Ruth Rawson, and Helen Martin. The band members were wearing new capes made by the PTA. Fund-raisers were held by the PTA and the Oceano Fire Department to buy the uniforms. (Courtesy of ODA.)

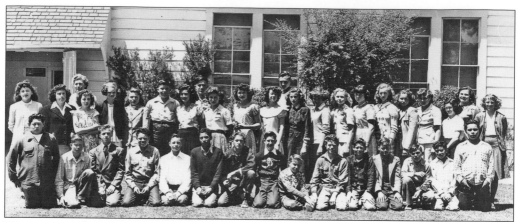

This group is the Oceano School graduation class of 1949. The principal was Frances Northey and the teacher was Margarita Howard. From left to right are (first row) Earl Souza, Charles Graves, Dick Coombs, Joe Calderon, Harold Bailey, Danny Sarmiento, Jerry Sproule, Gene Bray, Daniel Messer, Edgar Cassel, Ralph Close, Jon Gateley, Gayor Dague, Henry Castanares, Jesse Moreno; (second row) Dolores Padilla, Carmen Gonzales, Mrs. Howard, Yvonne Hart, Christine Cassel, Betty Pharr, Frank Molette, Della Faye Green, John Borba, Patty Anderson, Mary Jane Montgomery, Rita Rodgers, Ralph Godfrey, Marilyn Copeland, Diane Galbraith, Minnie Frye, Nancy Show, Lillie Toppet, Melba Williams, Marie Mayberry, Clara England, Marcella Rodgers, and Jo Freeda Spicer. (Courtesy of Jon Gateley.)

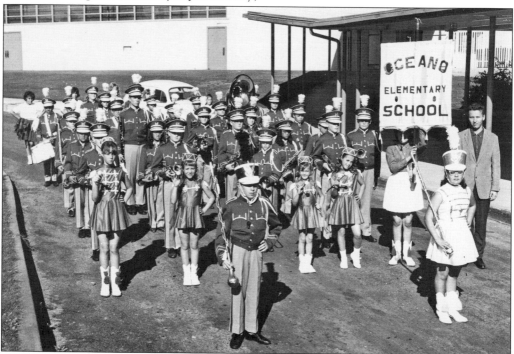

The Oceano Elementary School marching band is shown here in 1963. The marching band is in front of the Elementary School on Seventeenth Street, which was opened September 15, 1952. Pictured are (first row) Lenny Jones and Rose Remillard; (second row) Terry German, two unidentified, Pamela Mathiew, unidentified, and band instructor David Mallory. In the third row is Louis James, behind Pamela Mathiew. The rest are unidentified. (Courtesy of Wayne E. Allen.)

This is a photograph of the Oceano Grammar School staff in 1951. From left to right are Frances Northey, Paul Leitske, Minnie Godfrey, Charles Galbraith, Arletta Molette, Frank Murphy, and Hazel Atkins. This school was an enlargement of the original 1901 school and served the community until 1952, when the new school was built on Seventeenth Street. At this time, there were 528 students and 20 employees at the school. (ODA.)

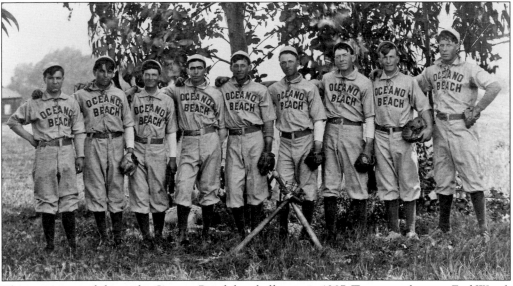

This rare postcard shows the Oceano Beach baseball team in 1907. Team members are Earl Wood, Ormond Lacefield, Lee Wood, ? Berta, Charles Dalessi, Roy Fisk, Bert Fowler, Tib Fisk, and Harry Fowler. (Courtesy of Ken Truelove; ODA.)

T. O. Thompson organized the Oceano Chamber of Commerce in 1923 and was its first president. The Oceano Chamber of Commerce was the only civic group in Oceano at that time, and they soon found themselves involved in such things as road improvement and abatement of the stray cattle and goats that were roaming the streets. (Courtesy of Jean Hubbard.)

This photograph of the T. O. Thompson home at 2431 Paso Robles Street was taken in 1938 from the windmill at the Dr. Rudolf W. Gerber home, which is in the foreground. In the distance (north), is a large apricot orchard. In the early days, Oceano was noted for being an excellent place to grow and process apricots for shipping. (Courtesy of Jean Hubbard.)

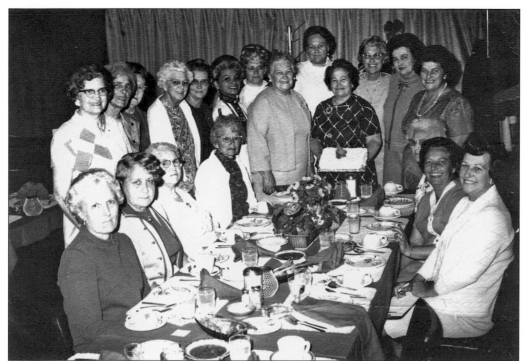

This photograph of the Oceano Women's Club Birthday Dinner was taken in the 1960s. Founded in 1944, the club became a very active civic group. Members are, from left to right, (seated) Ella Richards, Lena Gatlin, Grace Waldroupe, Carrie Cardoza, Arletta Molette (standing), Lena Angello (standing), unidentified, Dorothy Smith, and Doris Galbraith; (standing) unidentified, Leona Hero, unidentified, Marie Bray, unidentified, Vera Rivas, Sandra Strohman, Rose Baughman, Neva Hollibaugh, Kate Castner, and Florence Mintz. (Courtesy of Donna Angello.)

The Oceano Women's Club building was dedicated on September 11, 1949, and was attended by members of the Ladies Auxiliary of Oceano VFW Post No. 3138, which was instituted November 17, 1936. Donations of volunteer labor and material kept the cost to around $5,000. The building still stands on Nineteenth and Ocean Streets and is now the Boys and Girls Club. Shown here are Pearl Werling, Arletta Molette, and Shorty Dale. (Courtesy of Oceano Women's Club.)

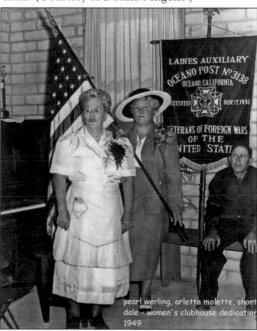

pearl werling, arletta molette, shorty dale - women's clubhouse dedication 1949

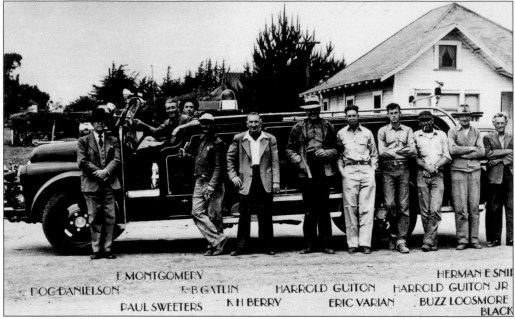

E MONTGOMERY
DOC DANIELSON R-B GATLIN HARROLD GUITON HARROLD GUITON JR
PAUL SWEETERS K H BERRY ERIC VARIAN BUZZ LOOSMORE
HERMAN E SNIP
BLACK

This 1950s view of the Oceano Volunteer Fire Department members is looking north across Paso Robles Street. Shown here are, from left to right, "Doc" Danielson, Emmett Montgomery (seated), Paul Sweeters (behind wheel), R. B. Gatlin, K. H. Berry, Harold Guiton Sr., Eric Varian, Harold Guiton Jr., Herman Snipple, Buzz Loosmore, and Mr. Black. The open-cab engine was a 1949 Dodge and was Oceano's first fire engine. (HEG.)

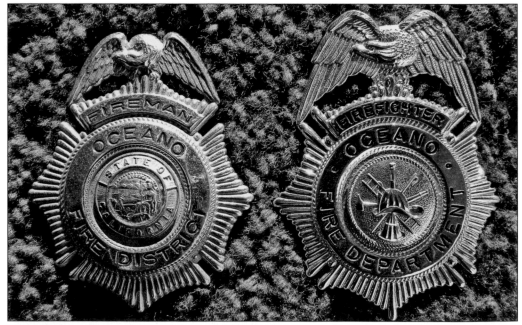

These badges reflect a change that occurred in the fire service throughout the United States during the 1970s. The "fireman" badge on the left is very gender specific, indicating an all-male occupation. The "firefighter" badge on the right came into use when women started coming into the fire service. Cindy Winter was Oceano's first female volunteer firefighter, serving from 1989 to 1991. (NRH.)

The Paul "Bud" Sweeters home is seen here on the north side of Paso Robles Street. This home was on Strand Way at one time, facing the ocean, and can be seen in the early photographs on pages 75 and 76. The home was moved to this location in 1911 and is still there today. Irene Sweeters is standing in the doorway. (Courtesy of Manuel Sebastian.)

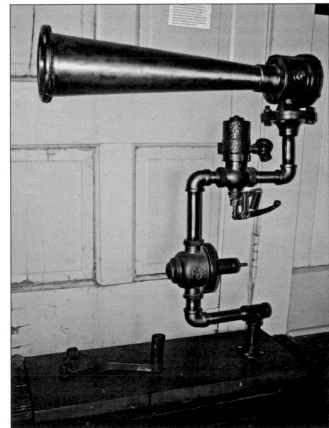

This air horn was powered with 90 psi of air. It was used to summon members of the Oceano Volunteer Fire Department to emergencies prior to the advent of radio pagers in the late 1970s. The horn was so loud it could be heard in Pismo Beach and on the Nipomo Mesa. It is now on display at the Oceano depot. (NRH.)

Wesley "Wes" Cook was very young when he joined the Oceano Volunteer Fire Department in 1952. The firefighters at that time were all so young that people in town affectionately called them the "Kindergarten Fire Department." Wes became fire chief after Chief John Bader died in the line of duty at a house fire on Pier Avenue in 1965. When Wes retired in 1981, he had been fire chief for 16 years. (Courtesy of Wes Cook.)

This rifle was a prize that was displayed in local taverns to sell raffle tickets to benefit the Oceano Volunteer Fire Department. Holding the 1983 winning ticket in Ralph and Duane's tavern in Arroyo Grande is Mike Forrest. Presenting the rifle is Oceano firefighter Manuel Vargas. Manuel joined the fire department at its founding in 1947 and was a volunteer for 42 years. (Courtesy of Oceano Firefighters Association.)

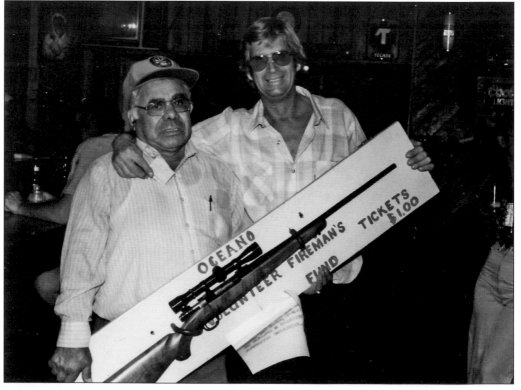

Manuel is seen here cooking at a 1981 fire department barbecue at Oceano Memorial Park. Since 2003, the Oceano Firefighters Association has continued to honor Manuel's 42 years of service with an annual Manuel Vargas Award that is given to firefighters who have shown exemplary service for that year. The award has some of Manuel's very last words, "Stay together. Watch out for each other." (Courtesy of Oceano Firefighters Association.)

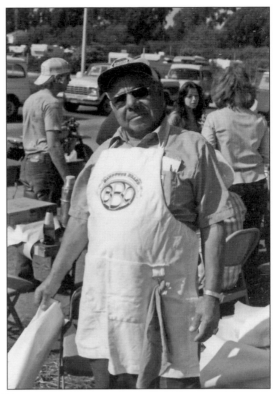

The lettering was put on this 1956 fire engine when Oceano was a fire district manned by volunteer firefighters and a board of fire commissioners. The engine sat in a field near Soledad after being sold at auction in the 1980s but was later traded back to Oceano in a swap arranged by Oceano resident David Angello. The engine is currently being restored by the Oceano Firefighters Association. (NRH.)

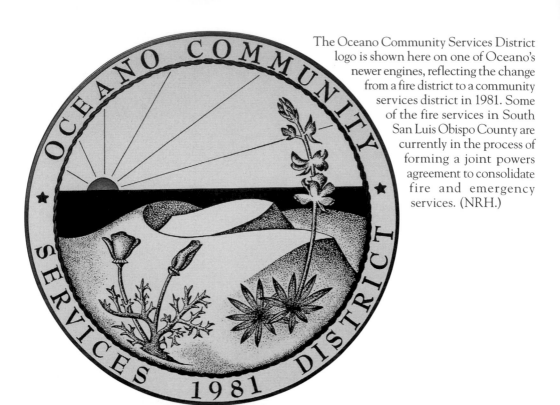

The Oceano Community Services District logo is shown here on one of Oceano's newer engines, reflecting the change from a fire district to a community services district in 1981. Some of the fire services in South San Luis Obispo County are currently in the process of forming a joint powers agreement to consolidate fire and emergency services. (NRH.)

The small "Triangle Park" on Highway 1 and Beach Street was constructed by the OIA and officially dedicated as Oceano's Bicentennial Park on November 26, 1976. Seen here during construction are Phil Davis, Frank Valesquez, Jim Guiton, Glenda Guiton, Linda Guiton, David Angello, Will Deschenes, and Harvey "Brownie" Brown (in car). In the background is St. Francis Church. (HEG.)

This stained glass window in the St. Francis Church features the Virgin of Guadalupe, patron Saint of Mexico. This building first began as the Episcopal St. Barnabas Mission Church in Arroyo Grande in 1901. By the late 1940s the congregation had outgrown the church, so it was moved to Oceano in 1950 where it became the Catholic Church of St. Francis of Assisi. (NRH.)

The OIA was founded in 1961 and sponsored the Oceano Centennial celebration at Oceano Memorial Park. Although Oceano is still an unincorporated area, it was proud to celebrate the 100th year from when Oceano first appeared as a place name on a map on June 3, 1893. The clam bell that once hung at Lovern's Clam Stand is being rung here by Norm Hammond to open the celebration. (Courtesy of Cindy Winter.)

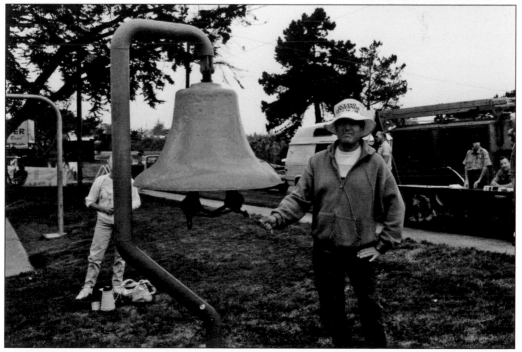

The OIA decided to place two entrance signs on each end of Highway 1 in Oceano. The two signs were completed and put in place in August 1986. Shown here after installing the sign on the east end of town (near Tierra Nueva) are OIA members Harold Guiton, Scott Wetmore, and Will Deschenes. (OIA.)

Al and Rose Baughman are longtime residents and civic leaders of Oceano. Rose is a longtime member of the Oceano Women's Club and was postmaster for many years, and Al is a longtime member of the OIA. Al and Rose are shown here with a plaque of appreciation at Far Western Tavern during an OIA Christmas dinner in 2007. (Courtesy of Linda Austin.)

Six

THE OCEANO LAGOON AND STATE PARK

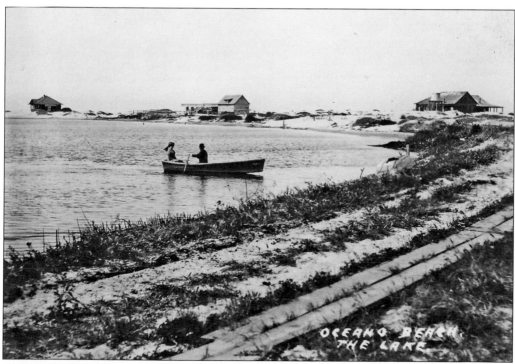

This view is from Juanita Avenue, looking west across the lagoon toward Strand Way and the ocean. The building on the left end of Strand Way is the "Bud" Sweeters home, which was moved to downtown Oceano in 1911. The structure on the far right was the first Oceano Beach Hotel, constructed in the early 1900s. This early beach hotel is featured on the cover of this book. (Photograph by Virgil Hodges; courtesy of ODA.)

Strand Way is seen here in the early 1900s as a peninsula that ends at the mouth of Arroyo Grande Creek, where it meets the ocean. The south end of the lagoon emptied directly into the ocean (left) prior to the installation of floodgates in 1957. The floodgates helped control the level of the lagoon during dry years and prevented water from the creek and ocean from flowing back into the lagoon during extremely high tides. (Photograph by Virgil Hodges; courtesy of ODA.)

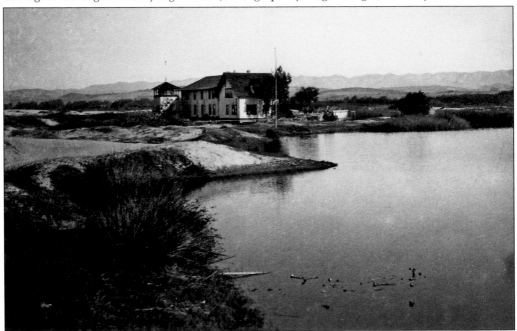

The first Oceano Beach Hotel was on the strand, facing the ocean (on the cover). The second Oceano Beach Hotel was this one on Juanita Avenue facing the lagoon and is seen here from the strand. This hotel later served as a Buddhist monastery in 1914, then became a private residence. (Courtesy of HEG.)

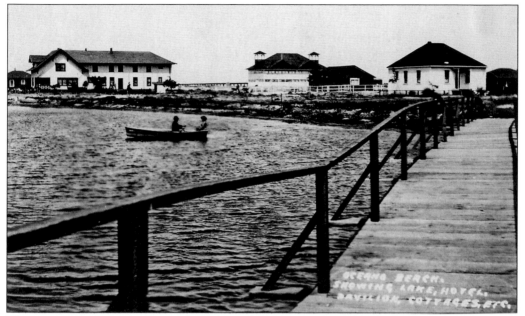

This view is looking northwest from the Lakeside Avenue Bridge from the south side of the lagoon. On the left is the second Oceano Beach Hotel to bear that name, constructed around the same time as the Oceano pavilion in 1907. The Oceano pavilion is seen to the right of the hotel. The building near the end of the bridge is a private residence. (Photograph by Virgil Hodges; courtesy of ODA.)

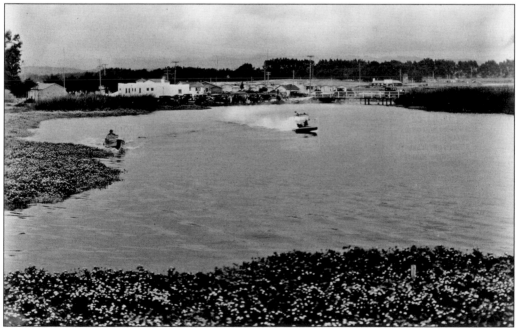

The lagoon was popular for many kinds of boats, including rowboats and sailboats. A speedboat is seen here racing in the waters of the lagoon west of Lakeside Avenue with a slower motorboat on the left. Parked cars and spectators line Juanita Avenue, with the Oceano Beach Auto Court and Lakeside Bridge on the right. (Courtesy of Bennett-Loomis Archives.)

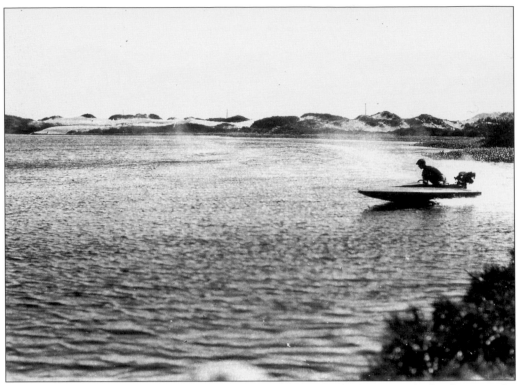

Seen from Strand Way is a motorboat racing full-throttle on the lagoon with the dunes in the background. Water skiing was a relatively new sport at this time, but occasionally a motorboat would be seen towing a water skier in the lagoon. (HEG.)

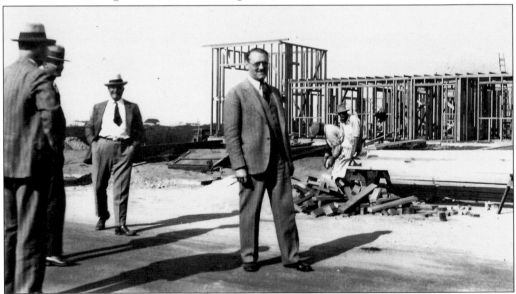

Bill Wise was a promoter of the Vista Del Encanto subdivision that borders the east side of the lagoon. His home was constructed on the corner of Roosevelt Drive (now Pier Avenue) and Norswing Drive. Irving Ryder was the contractor for this tract, and his name can still be seen where it was imprinted on the corners of some of the original sidewalks. (HEG.)

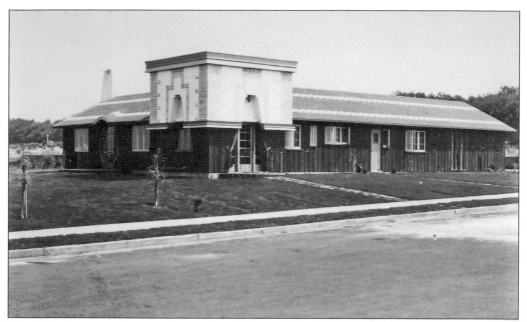

The Wise home was designed by architect Robert Stacy-Judd, known for utilizing Mayan motifs with art deco overtones in his work. The home had one of the few wine cellars in Oceano and a fish pond in the living room. The pond had a narrow outlet under the wall that connected it to a larger fish pond outside the home, allowing the fish to swim in and out of the house at will. (HEG.)

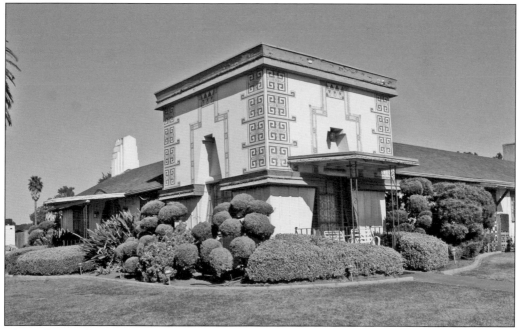

The Bill Wise home is still standing next-door to Old Juan's Cantina. The architect, Robert Stacy-Judd, was also a writer of books and articles about Mayan culture and architecture, and also Atlantis. Thousands of people on their way to the beach and sand dunes drive past this unique home during major holidays and weekends. (NRH.)

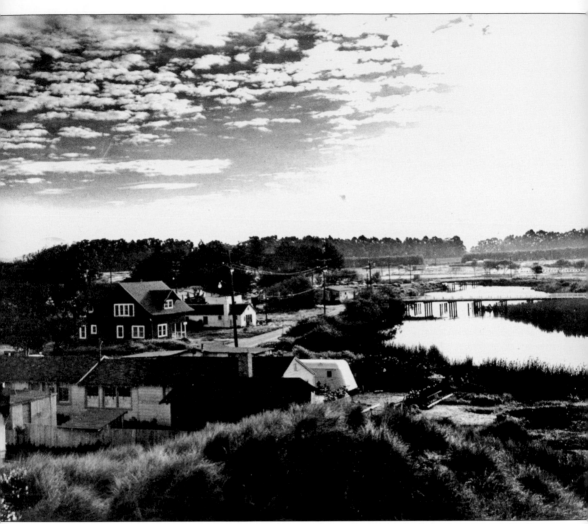

This photograph was taken from Strand Way in the early 1960s, looking east across the lagoon with Juanita Avenue on the left. Note the Lakeside (nearest) and Airpark Bridges crossing the lagoon. The Airpark Bridge was the original Pier Avenue, and when it was constructed, it was the only road access to the beach area. (Courtesy of ODA.)

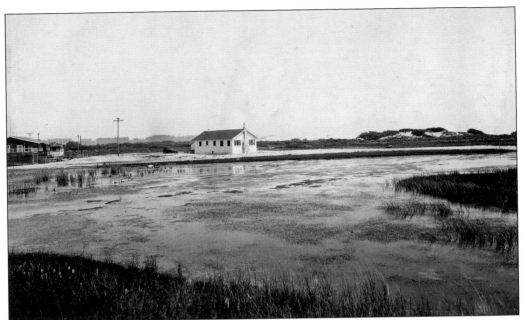

This view is looking southeast from Strand Way, across the lagoon area toward present-day Maui Circle. The center house was an early summer home built by vacationers escaping the inland heat. It still exists on the corner of Maui Circle. Just out of view on the left are some small cabins that were used by guests of the Honolulu Oil Company. The cabins are still there on Honolulu Street, which was named after them. (HEG.)

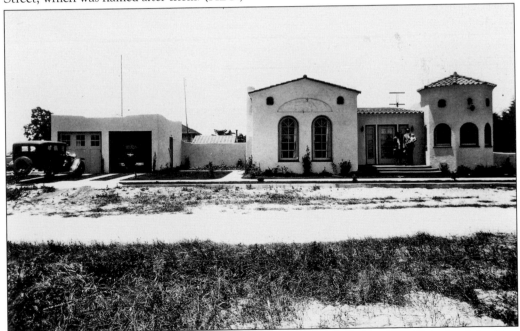

The Harold E. Guiton home and garage on Lakeside Avenue was built in 1927. This view is looking west in 1929 from the area of the present-day Elks Club. Although curbs and sidewalks are in place, the sandy streets in this section of town are not yet paved. Seen in the doorway are Harold Guiton Sr. and wife Reeta, holding Harold Guiton Jr. These buildings are still there. (HEG.)

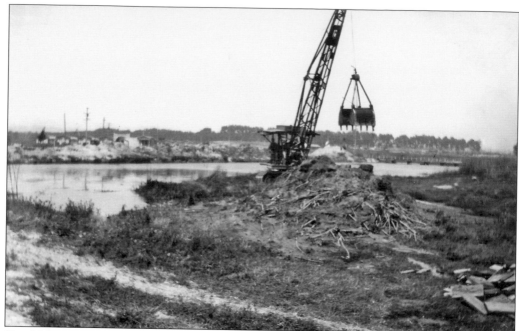

Harold Guiton Sr. was the first person to dredge the lagoon to enhance its recreational possibilities. This 1926 photograph looking northeast shows his dredge on the south side of the lagoon, between Lakeside Bridge and Airpark Bridge. The Oceano Beach Auto Court can be seen on the other side of the lagoon. Harold Guiton Sr. later deeded the lagoon area to the state. (HEG.)

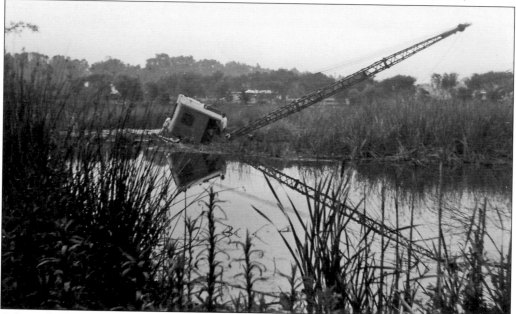

A later dredging operation done by the county and state in 1957–1958 was promoted by the Sportsmen's Club to offer a wider choice of freshwater sports, fishing, and boating near the surf. This operation got off to an auspicious start when the dredge began slipping in the soft mud. The dredge then toppled over and became almost completely submerged in the large open area of the lagoon. (HEG.)

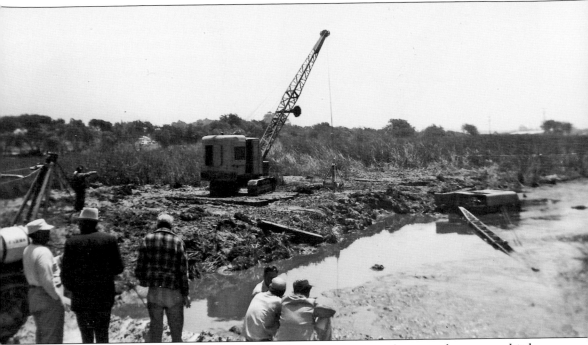

The easiest way to retrieve the submerged dredge was to remove the water from around it by draining that section of the lagoon. Truckloads of sand and gravel were dumped to create dams at the Pier Avenue and Airpark Bridges. The water was then pumped out of that area. This view of a crane trying to pull the exposed dredge out of the lagoon is looking south from the Airpark Bridge. Wetlands like the lagoon are now considered rare and sensitive habitats and dredging is seldom allowed. (HEG.)

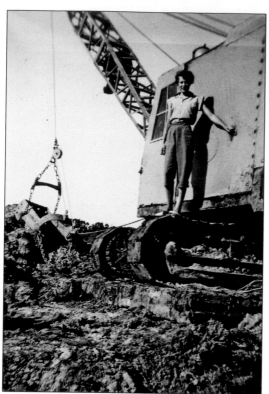

In 1958, Harold Guiton Jr. was the last person to dredge the lagoon at the county park. His sister Marie is seen here standing on the track of the dragline. This dredging operation was in the area of the Airpark Bridge. The dredge tailings were used to fill in the area where the county campground is now, along with the north end of the airport. (HEG.)

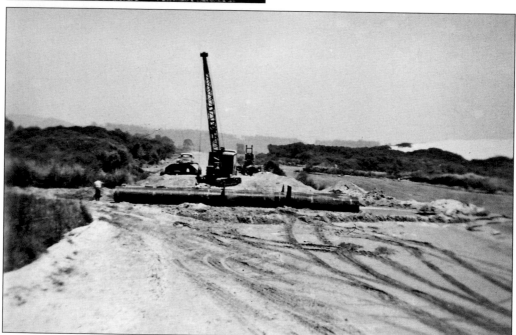

Extreme high tides during storms could sometimes raise the ocean level high enough to flow backward into the lagoon. To prevent this from occurring, culvert pipes and floodgates were installed on the south end of the lagoon where it empties into Arroyo Grande Creek and the ocean. Seen here is Harold Guiton Jr. operating the crane to install the floodgates in 1957. (HEG.)

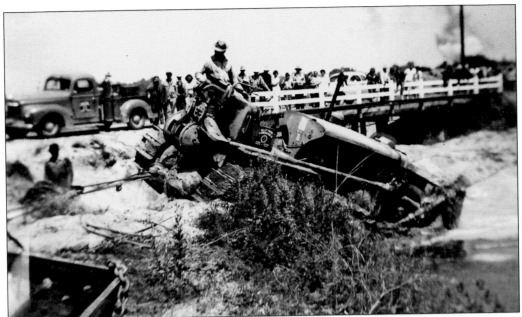

The wet, alluvial soil of the lagoon area can be very slippery for equipment working in that area. Here a D-8 Caterpillar that has slipped partway into the lagoon around 1956 is being pulled to safety. A crowd of people has gathered on the Airpark Bridge to watch the Caterpillar being pulled out of the lagoon. This view is looking east from between Airpark Bridge and Lakeside Bridge. (HEG.)

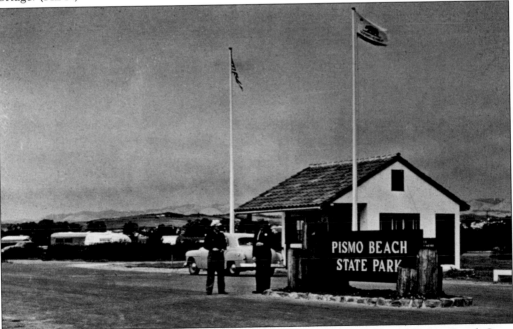

The state park entrance on Pier Avenue is seen here in the late 1940s. Although Pismo Beach State Park is miles from Pismo and bordered by Oceano on two sides, much of it still retains the Pismo Beach state name. This is a carryover from the early days when Pismo Beach originally ran south for many miles from Pismo, past Grover Beach and Oceano, and clear down to Oso Flaco. (ODA.)

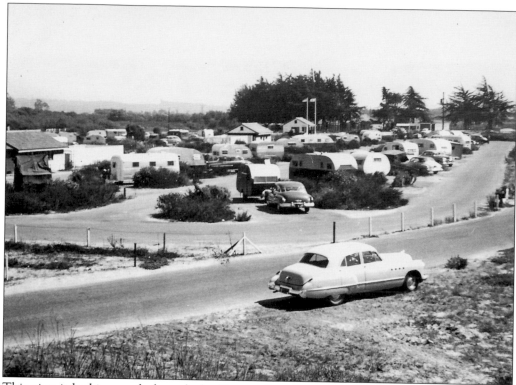

This view is looking south through the Oceano Campground in the early 1950s. The two flags at the Pier Avenue entrance to the park can be seen near the center of the photograph. The campground was built on 140 acres in 1947 and remains extremely popular with tourists, who must make reservations far in advance during the hot summer months of the year. (HEG.)

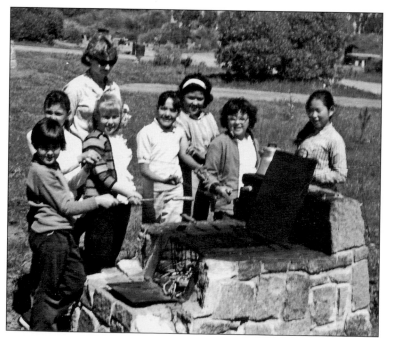

The Tawanka Camp Fire Girls are enjoying an outing in the state park in the early 1960s. Cooking hot dogs over the open fire are, from left to right, Vicki Rein, Susan Westberg, Glenda Guiton, Linda Guiton, Thelma Mata, Betty Cuellar, Virginia Remillard, and Aletha Sato. Susan was the daughter of Ray Westberg, the supervising ranger. These rock and mortar fire pits have since been replaced with round steel pits at the campsites. (ODA.)

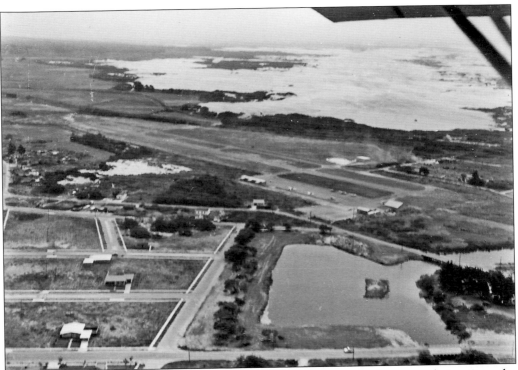

This aerial view taken in the mid-1950s is looking south across the lagoon and airport to the Oceano dunes. The largest part of the lagoon is in the foreground, with Pier Avenue running across the bottom of it. The small island in the lagoon is still there today. The road along the lagoon on the left is Norswing Avenue, which forms the western border of Vista Del Encanto. (Courtesy of Ada Blanchard.)

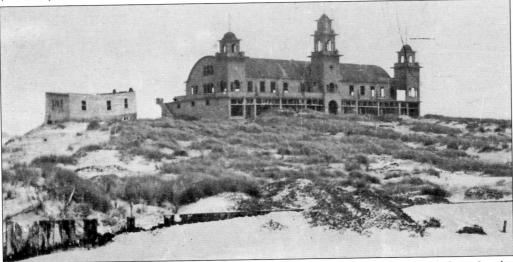

La Grande Pavilion was in the heart of the dunes, facing the ocean. It was located about 2 miles south of Arroyo Grande Creek. The creek forms the southern boundary of Oceano and is where the sand dunes begin. Nationwide advertising brought investors from almost every state to this planned community of 7,000 lots. The pavilion fell victim to the elements and was torn down for salvage in 1920. (HEG.)

Harold Guiton Sr. is shown here in front of his newly constructed auto court in 1924. This was the first auto court in Oceano and stood in the triangular piece of property between Pier Avenue and Airpark Bridge, where Pacific Plaza Resort is located today. The auto court was built from lumber that had been salvaged from La Grande Pavilion. (HEG.)

A portion of the auto court is shown here, being bulldozed by Don Cardoza in the early 1970s. Like many of the older structures in town that had outlived their usefulness, the remaining structures were burned down as a training exercise for the fire department. Live training exercises of this nature were common and extremely valuable for recruit firefighters in the past but are not as common today because of air pollution. (HEG.)

Seven

THE BEACH, CLAMS, AND DUNE BUGGIES

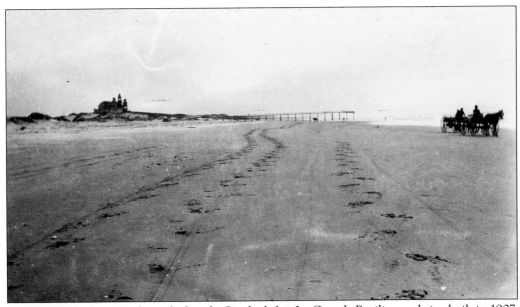

This view is looking south on the beach. On the left is La Grande Pavilion and pier, built in 1907. This pavilion was the largest and most ornate of the four pavilions on the southern coast of San Luis Obispo County. It was slated to be the center of La Grande, a city that was going to be built in the heart of the dunes. Access was by foot or horseback or with horse and buggy. (Photograph by Reeta Parrish; courtesy of HEG.)

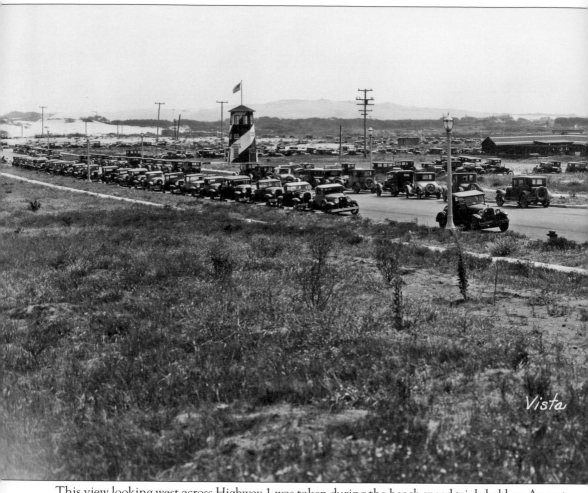

This view looking west across Highway 1 was taken during the beach speed trials held on August 31, 1931. The lighthouse building is the tract office of Bill Wise, developer of the new Vista Del Encanto subdivision in Oceano. This building was later moved west on Pier Avenue and now sits above the Elks Club building. (Photograph by Frank Aston; courtesy of HEG.)

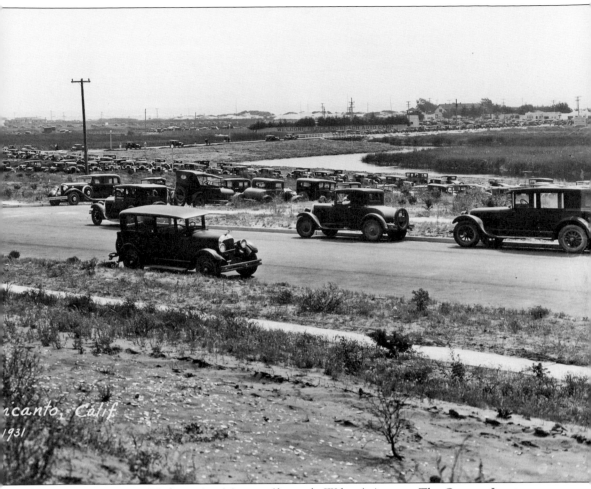

ncanto, Calif
1931

The street intersecting Highway 1 is Monroe (formerly Wilson) Avenue. The Oceano Lagoon can be seen making the turn before it passes beneath the newly constructed Pier Avenue Bridge. A sign on the far side of the lagoon reads, "Welcome to Oceano Beach Auto Camp." Most of the buildings seen in the distance are on Lakeside Avenue and are still there today. (Photograph by Frank Aston; courtesy of HEG.)

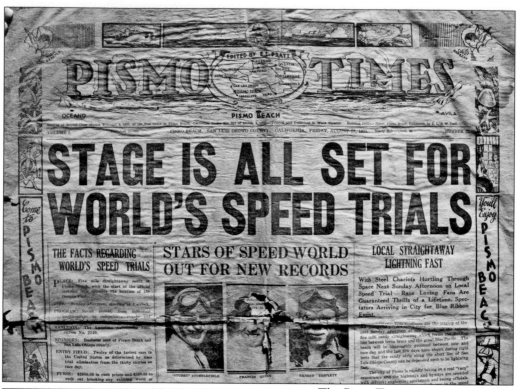

The *Pismo Times* newspaper headlines announced that an attempt at breaking the land speed world record of 245 miles an hour was planned on the beach at Oceano and Pismo. Beach conditions later required the attempt to be limited to smaller engines that were 183 to 305 cubic inches for safety. Both Ernie Triplett and "Stubby" Stubblefield won the day with speeds of over 130 miles per hour. (Photograph by NRH; courtesy of ODA.)

World's Speed Trials

DRIVER

PISMO BEACH CALIF.

Sunday, Aug. 30, 1931

During the 1931 speed trials, there were thousands of spectators trying to get onto the beach. This created problems with access, so there had to be some means of insuring that the drivers and their mechanics could come and go at will. These special driver's passes were issued to drivers who participated in the event. The passes are 3-1/8" tall, and 2-3/4" wide. (NRH.)

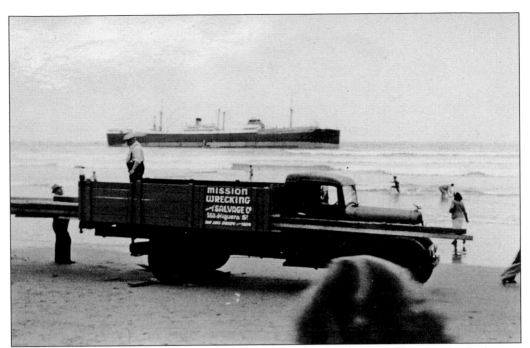

The Norwegian steamship *Elg* ran aground just south of Oceano in 1938 with a load of prime lumber from Vancouver, British Columbia. The only way the ship could free itself from the sandy bottom of the ocean was to jettison the lumber over the side of the ship and then wait for high tide. Many people came to pick up the lumber that washed up onto the beach. (HEG.)

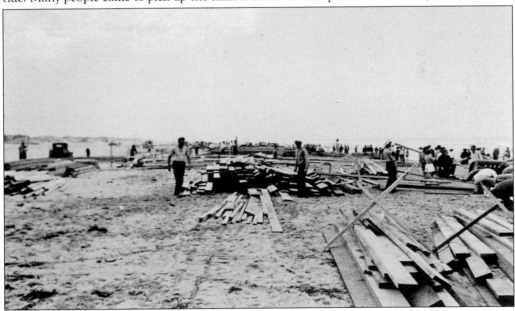

When word got around that there was free lumber washing up on the beach at Oceano, it started the equivalent of a gold rush. Martial law was finally declared until salvage rights could be determined. The lumber salvaged from the *Elg* heralded a construction boom throughout the county and inspired a 1939 ship float in the La Fiesta parade titled, "*Elg*–Oceano–Our Ship Came In." (HEG.)

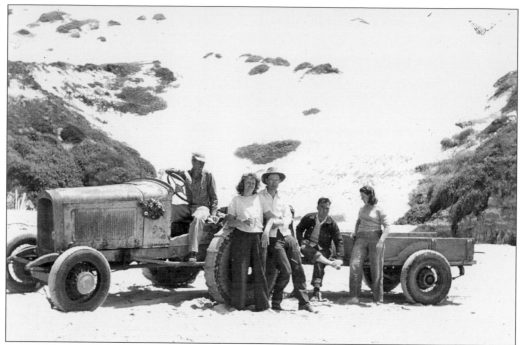

One of the first beach buggies was this one built in 1933, powered by a Star flathead six-cylinder engine. In the background is Devil's Slide, a 500-foot dune north of Mussel Rock that was a challenge for dune vehicles and a popular picnicking area for beach buggy enthusiasts. Pictured here in 1947 are Carl Beck, Frank and Joan Roesberry, and Marie and Louis James. (Courtesy of Geneva Beck.)

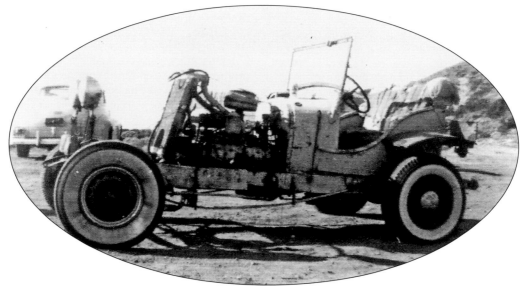

Jerry Miller was the first person in South San Luis Obispo County to move the engine in a dune buggy back toward the center of the frame. This proved to be effective in putting more weight on the rear wheels for traction in soft sand. Jerry's dune buggy was originally a 1932 Ford pickup that was stripped down, then had a Model T coupe body put on the frame. (Courtesy of Jerry Miller.)

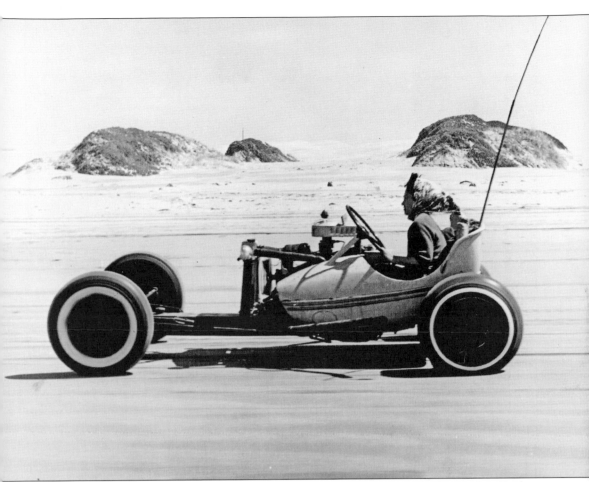

Evelyn Tallman, "The Purple Lady," is shown here driving "Betsy" in the late 1950s. Evelyn always liked purple and wore purple clothing while driving her lavender dune buggy. It was built by Arnold Teague, who was also an active member of the Dune Riders. The body was made from two inverted rear fenders from a 1946 Mercury. The dune buggy was powered by a V-8 engine from that same car. (Courtesy of Evelyn Tallman.)

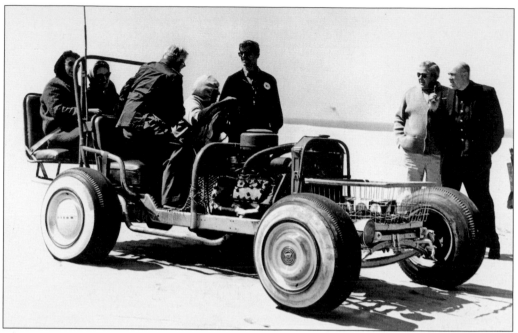

The Dune Riders Club was very active during the 1960s. Seen here is Don Snell, an avid dune enthusiast, giving a tour of the high dunes. The Dune Riders Club also hosted a group of young people from the Koshare Indian Tribe from Colorado every year to enjoy the dunes. (Courtesy of Evelyn Tallman.)

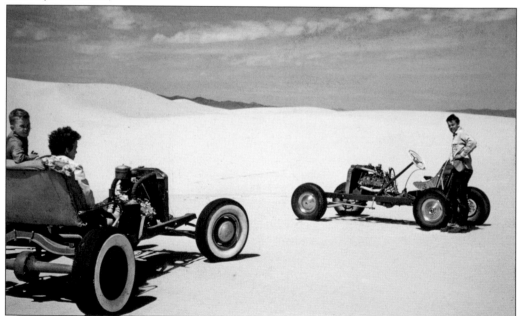

Classic dune buggies from the 1950s were made from old automobiles that were stripped down to just a frame, engine, and wheels. Following Jerry Miller's example, the engines were moved back toward the center of the frame. The seat was also moved back until it was directly over the rear axle to provide an even better weight distribution. Shown here are Donald and Mary Ann Hensley with Harold Guiton in the far dune buggy. (HEG.)

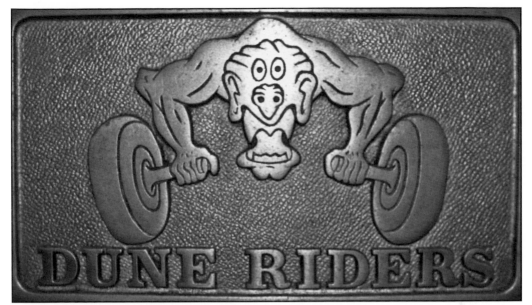

The Dune Riders Club was founded in March 1959 with Arnold Teague as its first president. The club was founded to promote safety on the beach and a better relationship between all beach buggy owners, law enforcement officers, and citizens in the area. By 1963, the Dune Riders had over 75 members from areas such as Hanford, Fresno, Los Angeles, and other places throughout California. (NRH.)

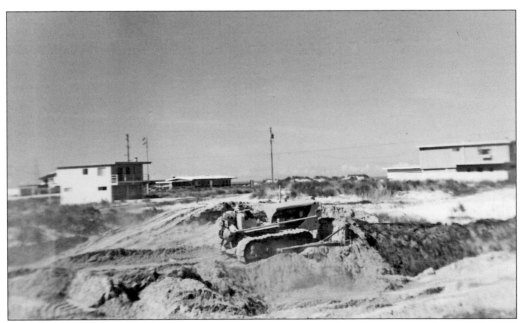

Harold Guiton Jr. is shown here on his D-8 Caterpillar clearing lots near the beach in 1966–1967. The lots are north of York Street, between the lagoon and Strand Way. On the left is 324 York Street, and 1655 Strand Way is on the right. There were many vacant lots in that area at that time, but with the increased demand for beachfront housing there are very few empty lots in this area today. (HEG.)

This home facing the ocean on Strand Way is being constructed by Fletcher Harvill. Built in the shape of a clam, the house was in perfect tune with a very popular natural resource. The rounded, open area facing the ocean where Ernie Renshaw (left) and the owner, Fletcher Harvill (right), are standing is the open-mouthed side of the clam. (Courtesy of Ernie Renshaw.)

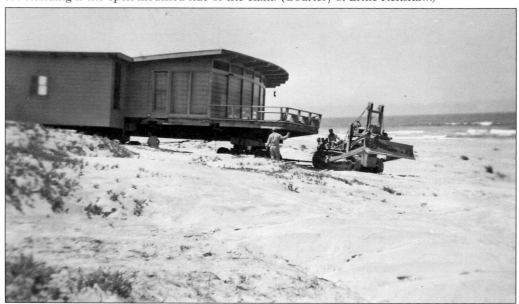

In 1957, the "Clam Shell House" was moved by Jerry Moore from its old location on Strand Way (between McCarthy and Juanita Avenue) to Norswing Drive and Monroe Street in the Vista Del Encanto subdivision. Harold Guiton Jr. is assisting in the move with his caterpillar. This home, with its unique design, is still standing. (HEG.)

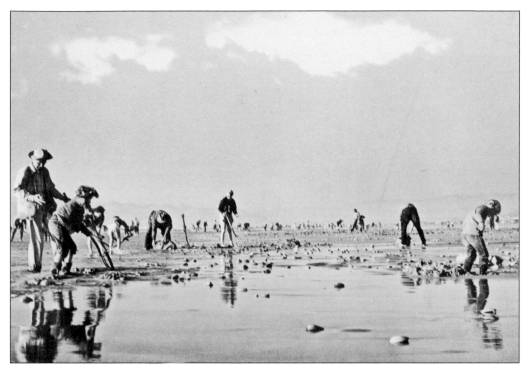

Clam digging was extremely popular with tourists and people who lived in the area during the 1940s through the 1970s. During holiday weekends that happened to have minus tides, people would almost be shoulder-to-shoulder in the surf. The clam size had to be 4.5 inches and the limit was 10 per day. Seen here is a very low tide in November 1949. (Courtesy of Sherwood "Woody" Gillette.)

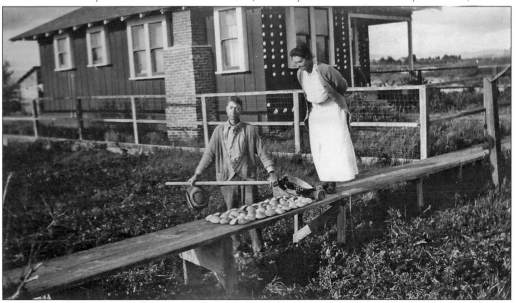

Pictured here with several limits of clams ready to be cleaned are Leonie Guiton and a friend. The house is on McCarthy Avenue, just a block or so away from the beach. For people living in Oceano during these times, clams were considered a delicious staple that was readily available. An old saying that reflected this sentiment was, "when the tide is out, the table is set!" (HEG.)

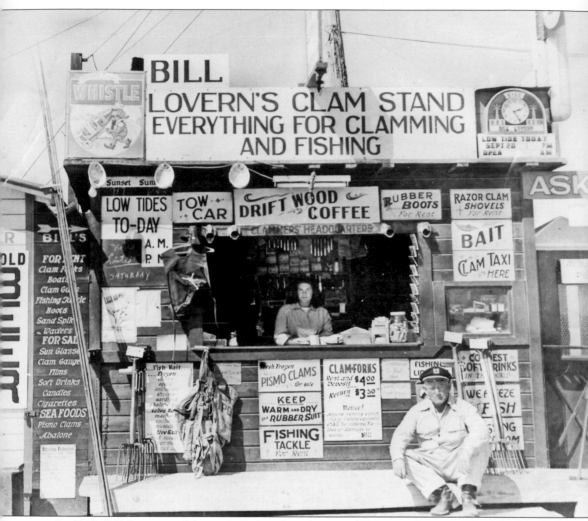

In 1948, Bill Lovern and his wife, Rubye, bought a small bait stand operation on the beach at the end of Pier Avenue. This later became Lovern's Clammers Headquarters in Oceano. Bill and Rubye made sure they had everything in their store that might possibly be needed by fishermen, clammers, and tourists camping on the beach. Betty Lovern is inside the store, with George Davis sitting on the walkway in 1956. (Courtesy of Rubye Lovern.)

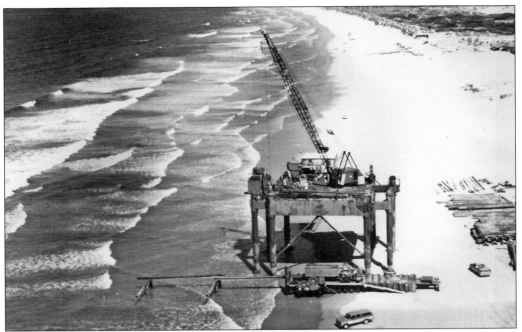

In 1979, a strange apparition appeared on the beach off Strand Way. Known as "The Spider," this movable crane was used to build a trestle to place a mile-long, 30-inch outfall pipeline from the Oceano sewage treatment plant a mile out into the ocean. The "legs" of the spider look like pier pilings and could actually move the apparatus slowly out into the surf, burying pipe as it went along. (Courtesy of Gina Davis.)

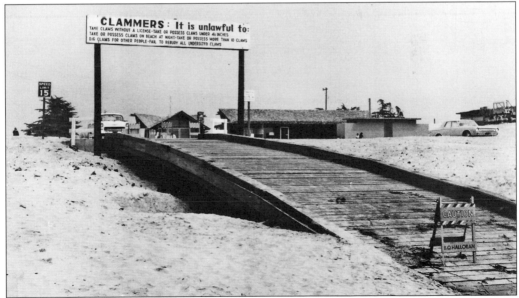

The wooden ramp going from the end of Pier Avenue down to the beach is shown here in the 1960s. The sign over the ramp states, "Clammers: it is unlawful to take clams without a license, take or possess clams under 4 ½ inches, take or possess clams on beach at night, take or possess more than 10 clams, dig clams for other people, fail to rebury all undersized clams." (Courtesy of *Times Press Recorder*.)

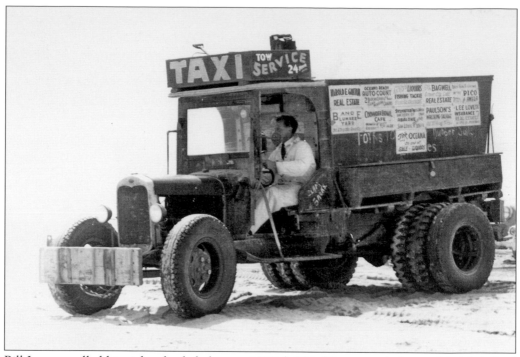

Bill Lovern called his eight-wheeled clam taxi "High Tide." It was made from a Model A Ford truck. People wanting to get to their favorite fishing or clamming spot but wanting to avoid getting stuck in the sand after winter storms would have Bill drive them there in his taxi. Note the advertisements local businesses placed on the sides of the taxi. (Courtesy of Rubye Lovern.)

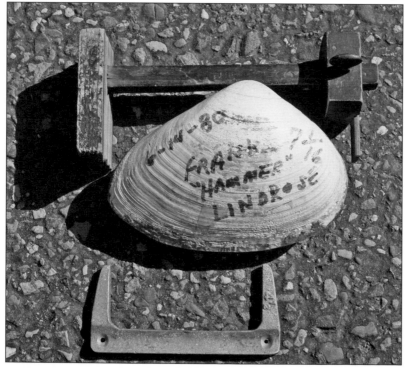

Bill Lovern would pay $10 to anyone with a clam larger than the one he had on display in his store. That clam would then replace the one that had been on display. This largest clam is 7.062 inches across. Above it is an adjustable gauge Bill made for measuring clams too large for a standard gauge. A standard 4.5-inch clam gauge is shown at the bottom. (NRH.)

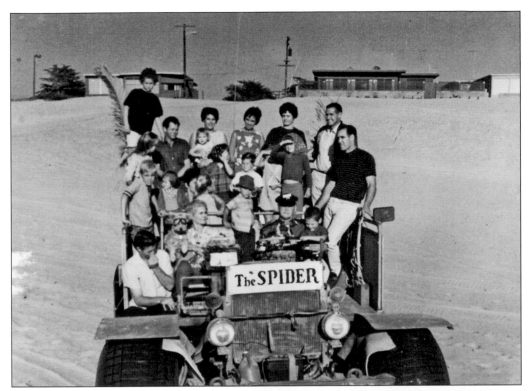

Members of the Lovern family are seen here in 1966 on Bill Lovern's beach vehicle, "The Spider," which was built by Bill Lovern's son Skip in 1961. Pictured are, from left to right, (first row) Phil, Rags the dog, Rubye, Bill, Brett; (second row) Sharon, Terri, Tracy, Maggie, Kellie, Skip; (third row) Rick, Gina, Melinda, Robin, Tye; (fourth row) Cindy, Richard, Betty holding Tommi, Louise, Barbara, and Billy. (Courtesy of Rubye Lovern.)

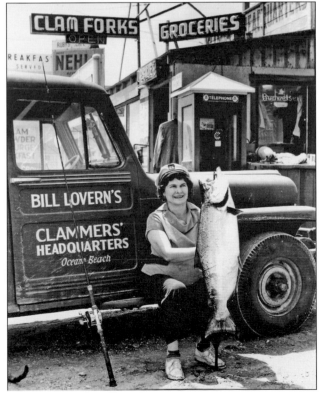

Rubye Lovern went clamming and fishing every day the tides and weather permitted during the first five years she lived in Oceano. She is shown here with a salmon she caught in the Ocean near Pier Avenue. In 1975, after almost 30 years of continuous operation, the Clammer's Headquarters was sold and the Loverns retired. (Courtesy of Rubye Lovern.)

LOW TIDES AT
OCEANO BEACH, FEBRUARY, 1953

Pacific Standard Time

Low Tides Date	Forenoon Time	ft.	Afternoon Time	ft
Feb 1 Su	4:55 a.m.	1.4	5:34 p.m.	0.0
Feb 2 M	5:34 a.m.	1.4	5:57 p.m.	0.4
Feb 3 T	6:17 a.m.	1.4	6:17 p.m.	0.8
Feb 4 W	7:09 a.m.	1.5	6:35 p.m.	1.3
Feb 5 Th	8:21 a.m.	1.4	6:52 p.m.	1.6
Feb 6 F	10:05 a.m.	1.3		
Feb 7 S	11:49 a.m.	0.8		
Feb 8 Su	12:50 p.m.	0.3	10.56 p.m.	2.5
Feb 9 M	1:34 p.m.	—0.3		
Feb. 10—Sunrise 6:49			Sunset 5:41	
Feb 10 T	12:16 a.m.	2.2	2:12 p.m.	—0.8
Feb 11 W	1:17 a.m.	1.9	2:48 p.m.	—1.2
Feb 12 Th	2:07 a.m.	1.4	3:24 p.m.	—1.4
Feb 13 F	2:57 a.m.	1.0	3:58 p.m.	—1.4
Feb 14 S	3:45 a.m.	0.6	4:33 p.m.	—1.1
Feb 15 Su	4:35 a.m.	0.4	5:08 p.m.	—0.7
Feb 16 M	5:27 a.m.	0.3	5:43 p.m.	—0.1
Feb 17 T	6:25 a.m.	0.4	6:18 p.m.	0.5
Feb 18 W	7:31 a.m.	0.4	6:54 p.m.	1.2
Feb 19 Th	8:56 a.m.	0.5	7:35 p.m.	1.8
Feb 20 F	10:39 a.m.	0.4	8:45 p.m.	2.3
Feb 21 S	12:08 p.m.	0.2	10:54 p.m.	2.5
Feb 22 Su	1:11 p.m.	—0.2		
Feb 23 M	12:25 a.m.	2.3	1:56 p.m.	—0.4
Feb 24 T	1:19 a.m.	2.1	2:31 p.m.	—0.5
Feb. 25—Sunrise 6:33			Sunset 5:54	
Feb 25 W	2:00 a.m.	1.8	3:00 p.m.	—0.5
Feb 26 Th	2:34 a.m.	1.4	3:25 p.m.	—0.4
Feb 27 F	3:05 a.m.	1.3	3:47 p.m.	—0.4
Feb 28 S	3:36 a.m.	1.0	4:09 p.m.	—0.2

*Compliments of

FORNEY'S LIQUORS
Owned and Operated by Forney Watson
WE ISSUE ANGLING AND HUNTING LICENSES

"If It Can Be Got, We'll Get It"

Front Street Oceano, Calif.

Forney Watson's Liquor Store was located on Front Street in Oceano, south of Beach Street. Forney posted a monthly tide chart in the store for his customers, clammers, and fishermen. "Minus" tides are the lowest tides, which are the best tides for clamming. This chart for February 1953 shows the lowest tides were on February 12 and February 13.

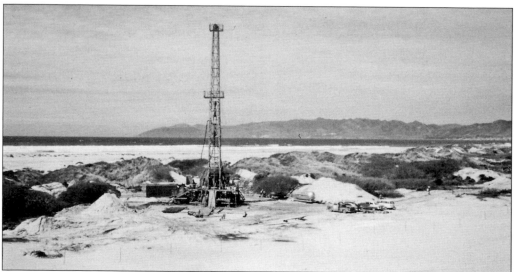

In February 1957, Alex Madonna contracted with Santa Maria Drilling Company to begin drilling a wildcat oil well on land he had leased in the dunes just south of Oceano. After drilling down 100 feet, they ran into hard rock but continued drilling. The job was suspended on May 24, 1957, after they had drilled exactly one mile down (5,280 feet) without hitting oil. (Photograph by Robert Guiton; courtesy of HEG.)

Crossing Arroyo Grande Creek going south from Oceano on the beach has always been hazardous, especially before Lopez dam was completed in 1968. Automobiles could get submerged while crossing during high tides that coincided with high creek levels during winter storms. Some cars would simply be abandoned, as this old-timer can testify. (Courtesy Gerber Family Papers.)

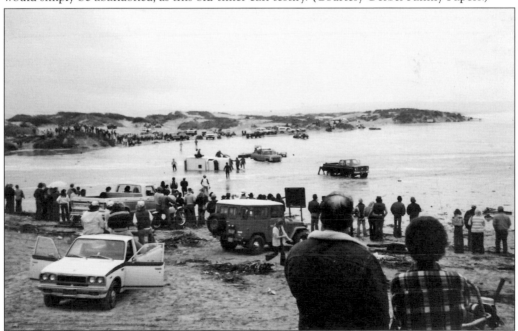

The state park and beach in Oceano are the only places left in California where people can still drive on the beach. The only way to drive south of Oceano is by crossing Arroyo Grande Creek. During the winter, the creek can be high and cars are often caught by waves from the ocean while trying to cross. A car seen here is already on its side and sinking fast. (HEG.)

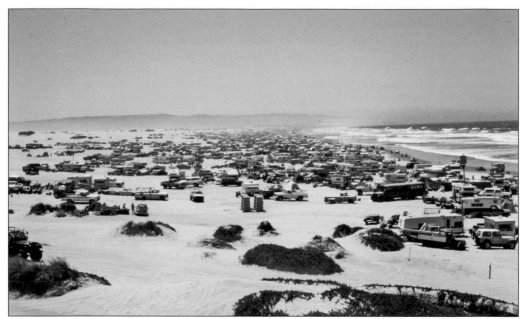

This photograph was taken before 1982, when the state began operating under a Coastal Commission permit establishing vehicle boundaries based on a number of issues concerning natural space, private property, and preservation. The view is looking south on the beach from a high place in the dunes during a major holiday. The terms of the permit brought about a reduction of people and traffic on the beach during major holidays. (HEG.)

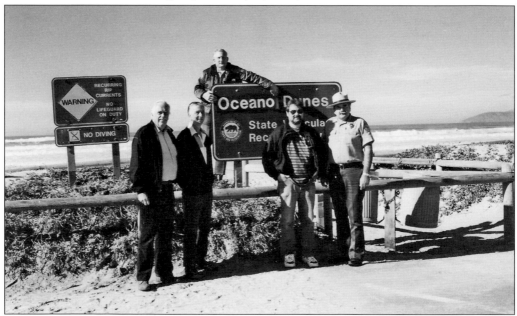

On December 19, 1995, this new "Oceano Dunes" sign replaced the old "Pismo Beach" SVRA sign. A concerned citizens' group, led by Jerry Esposito, lobbied the State Off Highway Vehicle Commission to effect the name change. Shown here with the new sign are, from left to right, Harold Guiton, Jerry Esposito, supervising ranger Roger Kellogg, Dave Angello, and district superintendent Don Patton. (HEG.)

Eight

THE OCEANO DEPOT AND MUSEUM

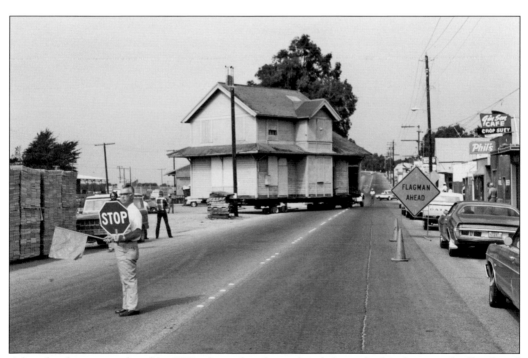

After the depot was closed in 1973, the railroad stipulated that it had to be moved off railroad property or be destroyed. In 1978, the depot was cut into two parts that were then moved .25 miles north from the old location on railroad property to the depot's present location. Shown here is half the depot being taken north on Highway 1, with Cecil Holmes as a flagman. (ODA.)

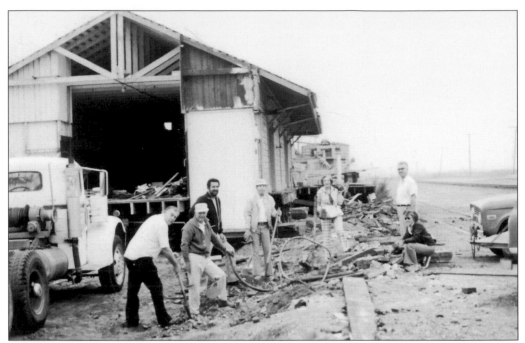

Members of the OIA are seen here preparing to move the second half of the depot. When the two halves of the depot were put together at the new location, they fit perfectly. From left to right are Harold, Stan Lundahl, George Allen, Al Baughman, Mary Lundahl, Cecil Holmes, and Glenda Guiton. (ODA.)

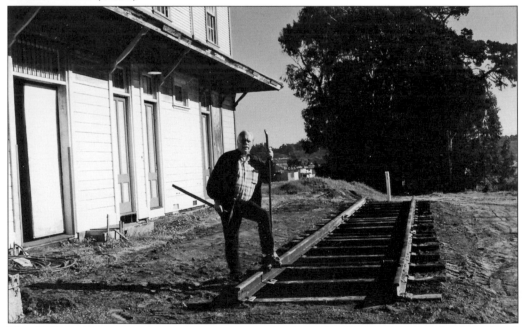

Harold Guiton Jr. was the prime mover in saving the depot from being torn down by the railroad after its closure in 1973. Once the depot was moved to its present location, Guiton was able to salvage some of the rails that had been in the railroad spur that ran from the depot to the beach. He is shown here in December 1997 placing those rails where the caboose sits today. (ODA.)

Harold Guiton jokingly referred to his track-laying project as the "Oceano and Northern Railway." This O&N herald commemorates Guiton's efforts in preserving Oceano's depot and railroad history, which continues on to this day. The caboose featured on the herald is patterned after the 1904 wooden caboose that is now on display at the depot. (NRH.)

The selling of "safe and sane" fireworks during Fourth of July season has been a long tradition in Oceano for nonprofit organizations. Harold Guiton is shown here inside a Freedom Fireworks stand selling fireworks to help fund maintenance and upkeep of the depot. At times, Harold would be assisted by the Kiwanis Club and other civic-minded members of the community. (HEG.)

In October 2004, Craig Angello, Jose Guevarra, and John Guiton moved a Railway Express Agency safe from Grover Beach to the depot. The safe was a generous donation of Dr. Manferd and Anita Shower, who acquired it from the old Railway Express Agency office in Paso Robles in 1969. The safe weighs over 2,000 pounds and is estimated to be over 100 years old. (ODA.)

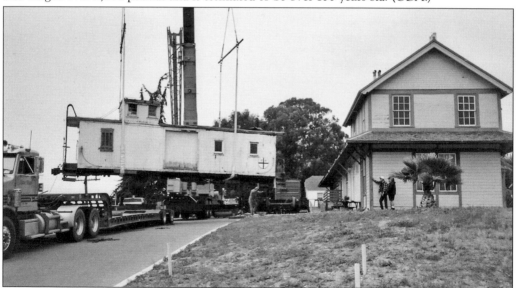

This 100-year-old wooden caboose was donated by John Loomis to the Oceano Depot Association in April 2004. It was then placed on a trailer with a large crane and moved from its location at the Tar Springs Ranch east of Arroyo Grande to the Oceano depot. It is seen here being lowered onto the wheel trucks that have been placed on rails next to the depot. (NRH.)

After restoration of the caboose, the Oceano Depot Association placed this plaque on the side. The plaque describes the long and colorful history of the caboose and how it has made its final trip to sit on the O&N rails placed by Harold Guiton at the Oceano depot. (NRH.)

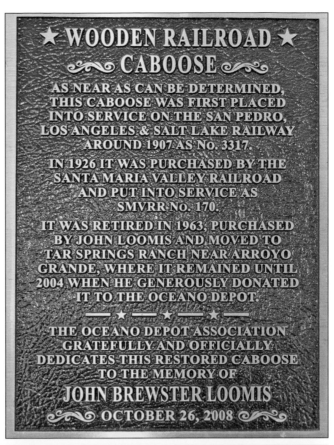

★ WOODEN RAILROAD ★
CABOOSE

AS NEAR AS CAN BE DETERMINED, THIS CABOOSE WAS FIRST PLACED INTO SERVICE ON THE SAN PEDRO, LOS ANGELES & SALT LAKE RAILWAY AROUND 1907 AS No. 3317.

IN 1926 IT WAS PURCHASED BY THE SANTA MARIA VALLEY RAILROAD AND PUT INTO SERVICE AS SMVRR No. 170.

IT WAS RETIRED IN 1963, PURCHASED BY JOHN LOOMIS AND MOVED TO TAR SPRINGS RANCH NEAR ARROYO GRANDE, WHERE IT REMAINED UNTIL 2004 WHEN HE GENEROUSLY DONATED IT TO THE OCEANO DEPOT.

—★—★—★—

THE OCEANO DEPOT ASSOCIATION GRATEFULLY AND OFFICIALLY DEDICATES THIS RESTORED CABOOSE TO THE MEMORY OF

JOHN BREWSTER LOOMIS
OCTOBER 26, 2008

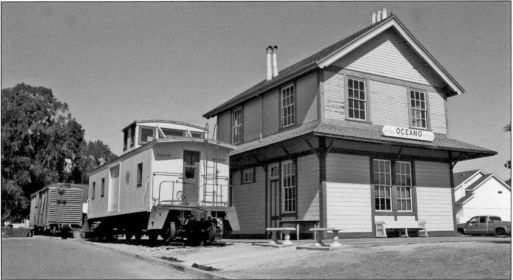

The depot, caboose, and boxcar are shown here from the depot parking lot. Behind the caboose is the 1958 Southern Pacific vintage boxcar that has been converted into a kitchen area and rest room. Most of the restoration and refurbishment work on the boxcar was accomplished with volunteer labor. A list of these contributors is mounted on the wall inside the boxcar. (NRH.)

In September 2005, Jim Guiton (in backhoe) and Roger Lippincott teamed up to place a concrete railroad phone booth in Gerber Park, which is behind the depot. Before the use of radios and GPS for communicating on the railroads, these booths were located at sidings on the main line for emergency communication between train crews and the dispatcher. Few of these phone booths are still in existence today. (ODA.)

Because the caboose ran on two different railroads, the heralds for both railroads have been painted on opposite sides of the caboose. The parking lot side has the old Los Angeles and Salt Lake Railway herald painted on it. Norm Hammond is shown here painting the later (1926) Santa Maria Valley Railroad herald on the side facing the depot. (Courtesy of Laurie Guiton.)

Carpenter Chuck Bachman regularly donates his carpentry skills to the restoration, maintenance, and upkeep of the depot, boxcar, and caboose. He is seen here working inside the depot boxcar. It is a late-1950s, vintage boxcar that has been converted into a kitchen area on one end and restrooms on the other. (ODA.)

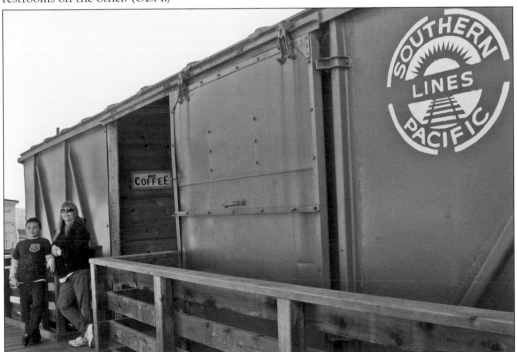

Ryan Knutson and Cindy Winter are seen here standing at the sliding door entrance to the depot boxcar. A handicap access ramp has been installed as a walkway leading up to the height of the boxcar and depot platform. The "hot coffee" sign seen just inside the door is the same one that was on the hamburger stand on Pier Avenue. This sign can also be seen on page 50. (NRH.)

Hap Corey was a barber in Oceano who had a son in the military during World War II. When people were getting a haircut, Hap would ask them if they had a family member in the military. If so, Hap asked them to bring a photograph of them to put on the wall. Shown here in 2006 is Hap Corey's son Jack. He is standing near his own photograph in his father's collection, which is now on display in the Oceano depot. (ODA.)

A World War II memorial monument was put together in 1949 by the Oceano Women's Club, honoring the eight men from Oceano who died in that conflict. In 2001, the monument was moved to higher ground at the Oceano depot so it would be more visible. Alex Ramey is driving the tractor and setting the monument in place. The Oceano Community Services District building is in the background. (ODA.)

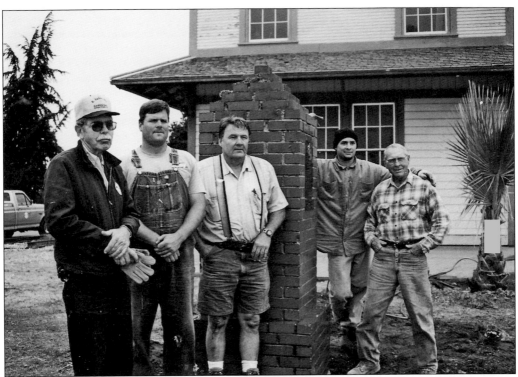

The monument now stands on higher ground, overlooking Highway 1. Standing next to the monument after being placed at its new location are, from left to right, Phil Davis, Ron Ramey, Alex Ramey, Richard Fonseca, and Ernie Clements. (ODA)

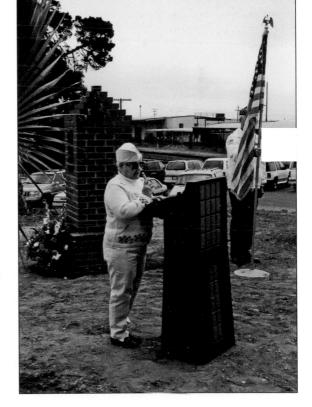

Nettie Belk spoke at the podium during the rededication of the Oceano World War II Veterans Memorial, September 15, 2001. Nettie was a chaplain for the Southwest Regional Gold Star Wives Association, longtime member of the Oceano Improvement Association, and ardent supporter of the Oceano Depot Association. (NRH.)

In March 2001, several *Washingtonia filifera* palm trees were planted on depot grounds. These are the same species of palm trees that were originally planted at the depot in 1904, when it was at its old location .25 miles south of where it sits today. Involved in the tree planting project are, from left to right, two helpers, Harold Guiton (left) and Larry Ramey. (ODA.)

The Clam Bell, which hung at the Clammers Headquarters on Pier Avenue, rang to alert people to low clamming tides and also emergencies. The Clam Bell was officially donated to the depot by Rubye Lovern on September 15, 2002. Seen here at the dedication are Jack Brackett, Rubye Lovern, and Ruth Brackett. (ODA.)

Bill and Rubye Lovern's granddaughter Kellie Boyd Myrick and their great-granddaughter Shawn Gill attended the dedication ceremony. Their uncle Bill had retired from 22 years of service in the coast guard, so they wore some old navy uniforms for the occasion. Clam chowder was donated by John Verdin of Old Juan's Cantina for the event. (ODA.)

In 2004, the Oceano depot had its 100th birthday celebration. No one knows exactly how old the depot is, but it was taken apart somewhere in the bay area and brought to Oceano and reassembled in 1904 by the railroad. Shown here are Patsy Darneal and Dale Esposito, who managed the souvenir booth at the celebration. (ODA.)

Tracy Boyd and Tye Lovern are placing commemorative bricks at the depot in 2003. The bricks are embossed with names of contributors to the Oceano Depot Association, names that honor families, friends, organizations, or those who are deceased. The bricks are sold to raise funds for depot maintenance and restoration. (ODA.)

Wally Seelos was a renowned baker and caterer for many years in the bay area. He and his wife, Dorothy, have volunteered for many of the social functions at the depot since they moved into the area. Seen here is Wally with a cake he made to commemorate the 100th anniversary of the depot, 1904–2004. (ODA.)

The San Luis Obispo County Board of Supervisors presented the Oceano depot with a resolution on the occasion of their 100th anniversary celebration in September 2004. The resolution commented on the important part the depot played in the area's history and honored the man who spent the last 25 years of his life devoted to its restoration. Seen here is Fourth District supervisor Katcho Achadjian and Glenda Guiton. (Courtesy of ODA.)

Organizers of the first-ever Oceano Grammar School Reunion in 2006 are, from left to right, Jeanne Scott Storton (1952), Arletta Molette Truesdale (1948), Erma Montgomery Kendrick (1948), Irene Montgomery Rodin (1952), and Linda Guiton Austin (1966). This event drew former students, teachers, and families from all over the western United States. (Courtesy of Manuele Photography.)

Capturing the spirit of the reunion is Rose Perez Bartlett, class of 1958, who attended with her five brothers and sisters, representing Oceano graduation classes from 1948 to 1965. The family wore T-shirts with their names: Ramon Velasquez, Angie Perez-Delagrande, Carmen Blackburn, Alice Tomas, Teresa Tilton-Simmons, and Frankie Perez. (Courtesy of Manuele Photography.)

A group of many former students and teachers are seen here in front of the depot caboose. The earliest graduate was Thelma Murray Anderson, class of 1933. All years up to the late 1960s were represented. Jon Gateley, class of 1949, served as master of ceremonies. The walls of the depot freight room were covered with class photographs and school memorabilia. (Courtesy of Manuele Photography.)

Nine

OCEANO TODAY

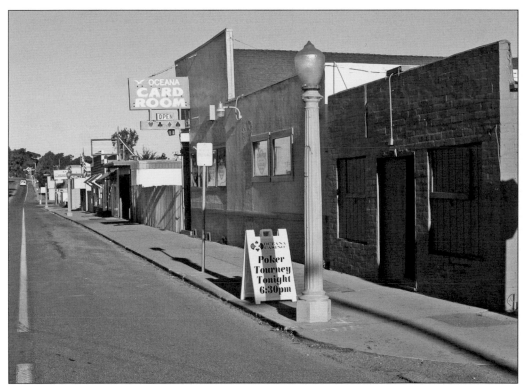

The downtown area of Oceano remains somewhat unchanged since the 1950s. This early-morning view is looking northwest on Highway 1 from Ocean Street. The antique lampposts that line the highway through town were installed in the 1920s. They have been restored to working order and continue to provide lighting along Highway 1 at night. (NRH.)

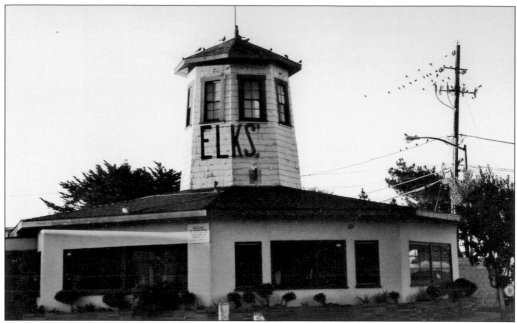

This tower structure was originally on the corner of Highway 1 and Pier Avenue (see also on page 90) and was a sales office for the Vista Del Encanto subdivision of Oceano in the late 1920s. It was moved to this new location in the late 1940s, where it became part of Skipper's Drive In, Oceano's first take-out restaurant. The tower is still there today, as part of the Elk's Lodge. (NRH.)

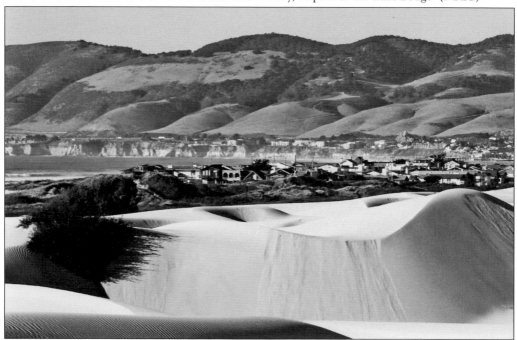

This view was taken from the dune preserve looking north toward Oceano. The dune preserve was created as a no-vehicle buffer zone between Oceano and the sand dune complex further south where all-terrain vehicles are allowed. Some of the homes in the Strand Way area can be seen beyond the dunes, and some of the houses in Pismo Beach can be seen across the bay. (NRH.)

When the new Oceano Post Office was dedicated in 1962, it also served as an informal meeting place for locals. Seen here in 1995 is Ed Ashley on his bicycle with his parrot and dog on one of his daily trips to the post office. Ed retired after 19 years as supervisor with the South San Luis Obispo County Sanitation District. Many people along his route to the post office looked forward to seeing Ed ride by on his bicycle with his pets. (NRH.)

A severe earthquake in 2003 damaged several streets in Oceano, as seen in this view of Coolidge Street looking east. The Oceano Airport was closed because of cracks in the runway, and many curbs and sidewalks were pushed out of alignment and had to be replaced. The western part of Oceano suffered the most damage, with the eastern part of town largely unscathed. (NRH.)

The Great American Melodrama was established in 1975 by John Schlenker and Annette Gillespie and continues to be a popular venue for live entertainment today. In keeping with old-time melodrama tradition, lots of booing and hissing takes place during shows. Customers are surprised to see the cast in their costumes serving food and drinks behind the bar during intermission. (NRH.)

Airpark Bridge is seen here from the east side of the lagoon, looking west toward the beach. The Oceano lagoon is regarded by many as being one of the crown jewels of Southern San Luis Obispo County. It remains popular with people camping in the state park, bird watchers, fishermen, and those who simply come to observe its natural beauty and abundant wildlife. (NRH.)

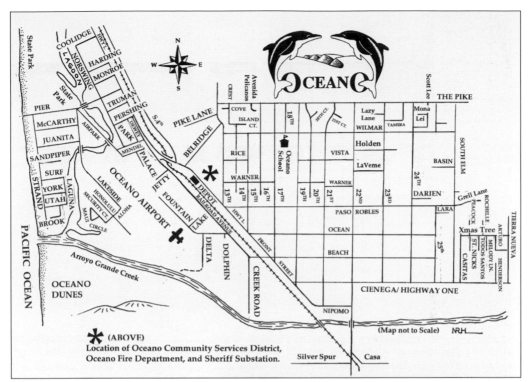

This map of Oceano shows its relation to the dunes. Oceano is separated from the dunes by Arroyo Grande Creek. (NRH.)

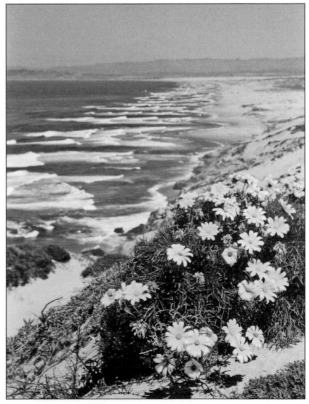

Looking north toward Oceano from the top of Mussel Rock, a stand of rare *Coreopsis gigantea* is visible in the foreground. There are about 12 miles of open beach and sand dunes from Mussel Rock to Oceano. Although vehicle access is permitted on some sections of the beach and park, few buildings or structures have been allowed. (NRH.)

Mark Weedon of Oceano enjoys driving his old-style dune buggy in the high dunes. The buggy was built in the late 1950s with a flathead Ford engine on a 1930 Model A Ford chassis. It was later repowered with a 1954 Buick 322-cubic-inch, V-8 engine and was featured in a 1963 article for the *Los Angeles Herald*. This view of Mark and his buggy in the Oceano dunes SVRA was taken in August 2009. (Photograph by Linda Austin; courtesy of ODA.)

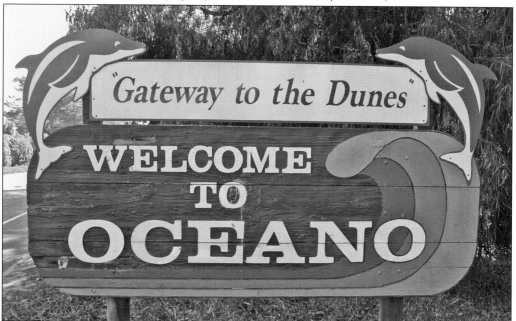

Highway 1 parallels the railroad tracks most of the way as it runs through Oceano. Entrance signs have been placed on each end of Highway 1 to welcome people entering or leaving town. Over the years, these happy dolphins have come to represent the wild and free spirit of Oceano. (NRH.)

About the Oceano Depot Association, Inc.

The Oceano Depot Association, Inc. is a nonprofit public benefit corporation. Articles of incorporation were filed with the Secretary of State on August 8, 1980. The specific purpose of this corporation is to restore, preserve, and operate the Oceano depot and other structures that have historical significance for the benefit of the residents and visitors to the community of Oceano.

All royalties earned from the sales of this book will benefit the Oceano Depot Association.

www.arcadiapublishing.com

Discover books about the town where you grew up, the cities where your friends and families live, the town where your parents met, or even that retirement spot you've been dreaming about. Our Web site provides history lovers with exclusive deals, advanced notification about new titles, e-mail alerts of author events, and much more.

MADE IN THE USA

Arcadia Publishing, the leading local history publisher in the United States, is committed to making history accessible and meaningful through publishing books that celebrate and preserve the heritage of America's people and places. Consistent with our mission to preserve history on a local level, this book was printed in South Carolina on American-made paper and manufactured entirely in the United States.

This book carries the accredited Forest Stewardship Council (FSC) label and is printed on 100 percent FSC-certified paper. Products carrying the FSC label are independently certified to assure consumers that they come from forests that are managed to meet the social, economic, and ecological needs of present and future generations.

FSC
Mixed Sources
Product group from well-managed forests and other controlled sources

Cert no. SW-COC-001530
www.fsc.org
© 1996 Forest Stewardship Council

Find Your Place in History.